The Beginner's Guide to Writing
KNITTING PATTERNS

Learn to Write
Patterns
Others Can
Knit

KATE ATHERLEY

INTERWEAVE.
interweave.com

CONTENTS

INTRODUCTION

What This Book Is

This book is a guide to writing knitting patterns: how to translate your great knitting project into a set of instructions that any other knitter can follow.

I provide concrete guidelines, with lots of examples, on topics including:

- **what information needs to be included in a knitting pattern**
- **how to properly and clearly communicate sizing and measurement information**
- **what schematics are, why you need them, and how to create them**
- **how to use charts and written instructions to express special pattern stitches such as cables and lace**
- **stitch nomenclature (especially related to cables), abbreviations, and glossaries**
- **how to handle multiple sizes and versions**
- **use of brackets and * to indicate repeats**
- **how to establish a personal style sheet**

And much more.

I discuss technical editing and test knitting—what they are, why they're important, and when they need to be done.

I give tips for designers who wish to self-publish, and for those preparing submissions to a publication.

In addition, I've provided a master template—both in printed and digital form—that you can use as a starting point for your patterns.

Who It's For

This book is for any knitter who creates his or her own designs and is looking to write instructions to allow others to knit those designs.

Whether you're a knitter who wants to create instructions to allow friends and family to make a hat just like yours, or you're a budding designer who wants to self-publish your designs or submit them to a publication, or you're an experienced designer looking for guidance to improve the quality of your written patterns, this book will help.

What It's About

This book specifically addresses the details of how to create complete, clear, and easy-to-use knitting patterns, for any type of design, and for any level of knitter.

What It's Not About

This book is not a comprehensive guide to knitwear design: It won't teach you how to come up with ideas or how to knit them.

Nor is it a book on sales or marketing or photography or graphic design and pattern layout: there are much better resources for that.

I'm not a lawyer, so this is definitely not a book about copyright (though I did consult a lawyer to prepare the chapter on this topic).

And being less than 300 pages long, there's absolutely no way this book is a guide to grading.

For all of these topics, however, I provide a high-level introduction, key tips on how to approach them, and pointers on where to learn more.

Why I've Written This Book

In addition to knitting and writing books about knitting, I spend my time doing two other things: teaching knitting classes and editing other designers' patterns.

I've been teaching knitting since 2001, and one of my favorite classes to teach is the Project Workshop. I've taught this class pretty much every week for over ten years. It's a non-specific class: knitters bring whatever they are working on, and I help them build the skills they need to finish it.

I've helped thousands of knitters with projects of all sorts, and I've seen thousands of knitting patterns, both good and bad. It's been an incredible experience and has given me a rather unique perspective: I see firsthand what knitters find easy and intuitive and helpful and fun in patterns, and what they find challenging and confusing and difficult.

This experience led me to start working as a technical editor. I review other designers' patterns for clarity and completeness and accuracy. I've edited more than ten major books from professional designers, and thousands of booklets and individual patterns from designers of all levels. My main job is as the managing technical editor for online magazine Knitty.com. I started there in 2008 as the resident sock expert, and it's this particular work that really brought it home to me how challenging and confusing and difficult it can be to write a good pattern.

When you're working with an experienced, previously published designer, the standard of pattern writing is usually good, and the technical editing job is typically confined to confirming the mathematics of the pattern. But *Knitty* prides itself on publishing all sorts of designers, both new and experienced (one of our recent issues

featured a fantastic sock pattern from a first-time designer: a fifteen-year-old young man with a bright future ahead of him). Being a great knitter with a creative mind doesn't naturally confer pattern-writing knowledge or skills. These newer designers sometimes need support with the mathematics, absolutely, but their questions are often more fundamental: what information is required in a pattern and how to present it; how to best articulate instructions; the whys and wherefores of charts, abbreviations; and so many others. It's my job to answer their questions, and my experience doing just that has informed my approach to writing this book.

Before I was a knit-design professional, I worked in the technology industry as a technical writer, product documentation specialist, and marketing communications expert. I spent fifteen years thinking about how to communicate complex concepts and multistep processes and procedures in a way that's easy to understand.

This book brings those skills and sets of experience together in an attempt to answer all the questions I've been asked over the years at *Knitty*. My aim is to apply some of the practical elements of technical writing to knitting pattern writing, with a view to making it easy for both designers and knitters.

Don't Just Take It From Me

What Knitters Like to See in Patterns

I've surveyed knitters—in person, over Twitter, and through my blog and the Knittyblog—for input on what they do and don't like to see in knitting patterns. I got so much great feedback that I decided to pass some of it along. Look for **Don't Just Take It From Me** sidebars throughout the book.

Why It Matters

It's simple: Good pattern writing matters because we want knitters to keep knitting.

Specifically, you want knitters to keep knitting your pattern—to finish the project they started. You want knitters to keep knitting your patterns—so that if they buy and make one of your designs, they buy and make others.

You and I want knitters to keep knitting so that they buy more patterns—supporting you, and providing me with ongoing technical editing work.

And the entire industry wants knitters to keep knitting so they buy more yarn and needles and books and magazines—to keep the industry going.

The best way to keep knitters knitting is to make sure they're enjoying it. And the best way to make sure they're enjoying it is to make sure it's easy and fun. The biggest part of that is to make sure patterns are clear and correct and easy and fun to work from.

Whether you're giving away your patterns for free, selling them, or submitting them to publications, you want everyone to enjoy your pattern: to enjoy looking at it, working from it, and showing off the finished project.

And it's not just about knitters, it's also about book and magazine editors. The better your patterns, the more likely they are to accept your designs and seek you out for future work.

This book aims to teach you everything you need to know to write high-quality patterns that will keep both knitters and editors happy. So let's get started.

Pattern Structure & Elements

In This Chapter

What to Include

A knitting pattern needs to contain all the information required for someone to reproduce exactly what you've made.

In addition, a knitting pattern needs to contain all the information required so that someone can successfully follow your instructions. That is, it's not enough to give an instruction; knitters have got to be able to understand it.

Your knitting pattern needs to include the following sections of information:

- Name of the pattern
- Photographs
- Introduction
- Level of difficulty/skills required
- Materials list
- Gauge
- Size information
- Abbreviations, glossary, references, techniques
- Pattern notes
- Instructions
- Designer's contact information, bio, credits
- Copyright statement
- Date, version number

The downloadable template (also printed in Appendix A on page 111) provides a basic pattern outline with all of these elements, and boilerplate info for each of them, as appropriate.

I'll talk about each of these in detail in this section.

Pattern Name

You can name a pattern whatever you want. It's tough to be original, given the number of published patterns, but aim for something that at least hasn't been used very much.

A pattern is going to sell better if it has a fun, interesting, or evocative name, rather than a plain descriptive name. A few years ago, another designer and I published very similar basic, non-lacy shawl patterns. Mine is called The Basic Triangle Shawl. The other one is called Boneyard. You can guess which one has been more popular. (See later in this section for suggested sources of pattern names.)

A few things to keep in mind:

> Check Ravelry.com and Patternfish.com to see if a pattern with your chosen name exists already. Your name doesn't have to be unique, but it's best if it hasn't been used for that type of item before. For example, I recently designed a sock I named Lindisfarne. There is another sock with that name, but the two designs are very different: mine is colorwork, the other is lace.

> Check Wikipedia to get a sense of what other things might share the name. Seasonale seemed like a great name for a nature-inspired lace scarf, until I discovered it was also the name of a brand of birth control pills.

> Check Babelfish.com (or another translation website) to make sure that the name isn't offensive or sending an inadvertent message in another language. It's an old story, still very relevant: in the 1970s, the car manufacturer Chevrolet sold a car called the "Nova." They couldn't figure out why it wasn't selling well in Mexico until someone pointed out that "no va" means "does not go" in Spanish.

Good Sources for Pattern Names

Dictionaries: Especially those focusing on historical, technical, or foreign terms. Or, obviously, translation software. There's a lovely pattern for a knit skirt called "Falda," which is simply the Spanish word for skirt.

Roadmaps and atlases: I use road names a lot when I name patterns. Sometimes it's obvious, sometimes it's not. I have a sock named Wellington

Road, after the road I lived on when I was a young girl. I also have a sock named Wellesley, after a street in Toronto where I live now.

Music and musicians: I've named many patterns after songs, and a few after musicians—for example, my Jarvis sock.

Movies and books, or characters in them: I once named a pattern after the 1932 ethnographic documentary *Man of Aran*.

Science: Hunter Hammersen has published three books of designs whose inspiration—and names—come from old botanical texts.

Historical figures, sports heroes, etc.

Photographs

The photographs accompanying your pattern should *clearly* show the finished item.

If it's a garment, it needs to be shown on an appropriately sized model. A sweater lying flat on a table gives no sense of the fit. And if it's being modeled, avoid fancy poses. If the model is seated, it's hard to get a sense of the length of the garment. You need to see the full arm if the garment has a sleeve. Make sure the model's hair is out of the way; too many collars get covered up.

Give multiple views of the design that are clear and well-lit. Show a long shot of the item, styled simply but nicely, and then closer views of the construction and fit details. If it's an interesting stitch pattern, show a close-up of the fabric.

Look at the photos on this page. The photo on the right works well, as you're able to clearly see all the key details: the shape of the garment, the length of body and sleeve, the neckline, and the fastening.

If the design is a shawl or wrap, show it both worn and lying flat so you can see the shape and size, and how to wear it; if it's an unusual shape, consider showing multiple ways of wearing it. If it's a blanket, make sure you can see the fabric up close, but also provide a photo to convey a sense of the size and shape of the whole thing.

One of the biggest sources of knitter unhappiness with a finished project is that "it doesn't look like

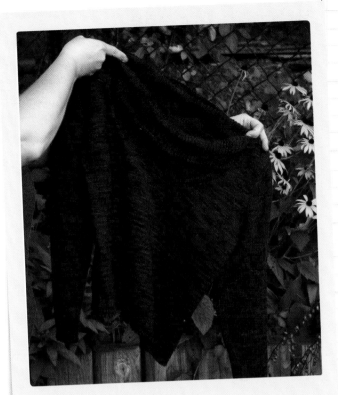

No, thank you.

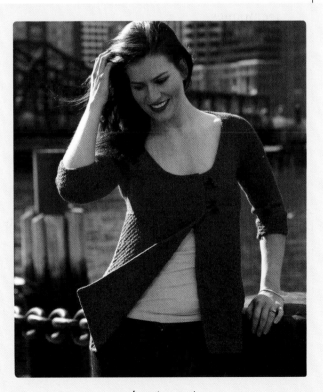

Yes, please!

it does in the photos." There are many possible reasons for this, including:

The "cheat" issue: Fashion magazines do this all the time: they pin or adjust or alter the garments to fit the model. If you're doing this, you're not properly showing the garment.

The fit issue: You've presumably knitted the sample to fit your model, and if the knitter hasn't chosen their own size appropriately, it won't look the same. Help the knitter choose the right size by providing lots of detail in the sizing information section of the pattern. (See page 24.)

The style issue: Most garments suit some body types better than others. It's possible the garment isn't as flattering a style on the knitter as it is on the model. Notes about the style and fit of the garment are an excellent addition to the pattern introduction. (See Intrigue, page 12.)

The styling issue: If you've photographed a vest with a crisp, fitted white shirt under it, and the knitter isn't dressed the same way, it's going to

Don't Just Take It From Me

I like at least one photo to be of the entire item without creative styling (like, not just a photo from the front of a shawl draped on a body).

I won't buy a pattern if there aren't photos of the entire thing (yes, I do want to see the back of a sweater, the bottoms of sleeves, etc.). I also tend not to buy patterns if there aren't photos of the item on a body (e.g., sweater patterns only photographed lying flat).

ADVICE FROM AN EXPERT: Knitter & Photographer Caro Sheridan

What are some simple things designers can do to make their photos better?

Take your time: You've already spent twenty, forty, or even more hours designing and knitting—spend one more hour to make your work look its best.

Turn your flash off! A flash is a direct, head-on light that will wash out all the bumps in your knits. Natural light is best. Best of all: go outside on a slightly overcast day, or work in the shade. Direct sun is too bright and creates too much contrast and too many shadows. If the lighting you use comes from the side, it better highlights the texture of your fabric.

Work with the tools you have: You can take good photos with a point-and-shoot camera, and even the simplest of photo editing tools allow you to crop photos the way you need.

Take a look at the background of the photos: A background that is too busy is distracting.

If you're working with another photographer, whether a friend, a photography student, or a professional, make it clear to them what the objective of the shoot is. This isn't a portrait. Remember that, too, if working with a model: If the model puts her hand on her hip, make sure she's not hiding parts of the garment, or pulling or smushing the fabric; have the model rest her hand lightly on her hip so that the fabric is undisturbed.

When choosing images to include in your pattern and to upload to online sales sites, don't overwhelm. Choose your "hero shot," and have a small number of good supporting images. Showcasing multiple minor variations of the same pose or detail doesn't add any value.

Caro has a couple of great tools to help you: a well-illustrated article full of easy tips for dramatically improving your photography: http://bit.ly/1y04d7i and a Craftsy class: http://craftsy.me/1FdqrUL

ADVICE FROM AN EXPERT: knitty.com Editor Amy Singer

Choose a person to model the garment who is comfortable in their own skin. If it's not you, then perhaps a friend who always smiles naturally and looks great in photos. Now, as awkward as it may seem (at first… trust me, you'll get used to it), you need to play stylist. Your model—or you—needs to be wearing something that complements but doesn't distract from the garment. Nothing else knitted should be in the shot; it confuses the viewer. Choose neutral colors that make the knitted garment the focus of attention. Avoid prints that might date the photo. Often, a simple black, white or cream-colored long-sleeved tee is a good choice. Take a few minutes to primp the model's hair and always apply mascara and lipgloss (at minimum). Gentle makeup is a necessity in photographs, even if it's not something the model normally wears.

When it comes to posing, simply don't. No hands on hips, no awkward fixed smiles into the camera. Instead, have your model move slowly in an interesting location. Change body positions often, and find something that makes sense for the model to be doing with her hands. Shoot your garment from all angles: front, back, sides. Close-ups of key design details are really useful for knitters and will make them love your work even more, since they won't have to guess how the collar was worked, for example.

The best advice I can give you is to shoot a lot and then keep shooting. Digital photography makes this easy—it doesn't cost a cent to shoot a thousand pictures. And the best way to get a really stellar shot is to do just that.

look different. Making a few comments about how the garment has been styled in your pattern introduction helps a lot.

The objective with your pattern photos is to convey valuable information about the design, not to deceive, overstyle, or obscure details.

There are also layout considerations when a pattern is photo-heavy. See Chapter 5: Formatting and Layout on page 82 for pointers on that.

The Introduction

The introduction of a knitting pattern has three functions: to intrigue, to entice, and to inform.

The objective is to give the knitters enough information to allow them to figure out if they want to knit it. A well-written introduction gives knitters confidence that the pattern is well-thought-out, complete, and helpful. The mere existence of an introduction makes the pattern better. And if you're submitting to a publication for consideration, use the introduction to sell and explain the design to the editor.

Don't Just Take It From Me

I love it when patterns tell me what size the model in the picture is wearing, what size her bust measurement is, and the amount of ease in the garment (plus whether it's positive or negative!).

I find it infuriating when you are only told the size of the garment and have to guess at whether the model looks bigger or smaller than that—I'd much rather not be told at all than be told half of what I need to know.

For shawls, I like to see a picture of the shawl laid out flat. Sometimes I can't quite tell what shape a shawl is when it's draped over someone's shoulders.

Don't Just Take It From Me

> I love a story at the beginning... A piece of knitting with a backstory will hook me so much more frequently than one without.

> I want a narrative for a pattern. What's the inspiration for it?

> I really dislike it when a designer writes a blurb calling their own pattern "beautiful" or "exquisite"—I'll be the judge of that, thank you! I want practical details in the description, like whether the design is intricate or simple, how it is constructed, what techniques are used, and, for shawls, what shape it is.

INTRIGUE: Get me interested in the project. A knitting pattern is, first and foremost, a set of instructions to make a *thing*. The introduction (supporting the photos, of course) should make the knitters want that thing. They should want to wear that sweater, or that scarf. They should want to give that hat to their partner who has to walk the dog on a cold winter's night. They should want to make those booties for a shower gift for a special baby.

Tell me what's interesting or unique or cool or different about the finished item.

Tell me a story: there's a lovely pair of lace socks on *Knitty*, designed by Brenda Patipa. She named them Tribute and tells us that they were inspired by a dear friend, also a knitter, who had recently died. This dear friend had a favorite stitch pattern, and the socks used it to great effect. Many knitters have made these socks as gifts for treasured friends.

And if it's a garment, tell me about how it will fit and flatter me. Consider making some (positive) comments about what body types and shapes the garment flatters best and how it is to be worn, such as:

This style of sweater is terrific for curvy women of all sizes.

This wrap-style cardigan flatters and adds curves to straight figures.

This jacket is terrific for office wear, worn over a crisp white shirt.

This basic shape is a good layering piece, and although it's not body-conscious, it will keep you very warm and comfy on long winter dog walks.

This might, of course, have the opposite effect. Some knitters might use this information to decide not to knit your pattern. But that's not a bad thing. I'd rather have one knitter make my garment and look fantastic in it and talk about it happily than have ten knitters wearing garments that don't suit or fit them.

ENTICE: Make me want to knit it. The introduction should make knitters want to use your instructions to make that thing.

There are relatively few entirely original patterns out there. In fact, there are *literally* thousands and thousands of patterns for worsted-weight ribbed hats for men. Why is your pattern the best one to use?

If the item is very new and different or done in an interesting way, explain that. Have you used an interesting stitch pattern or an unusual technique?

Is it challenging and engaging knitting that will teach a lot of new skills? Or, equally, is it plain and simple knitting, ideal for working on while watching TV or while commuting to work on the train?

Are you solving a problem? For example, is your pattern a good stash-buster, or an ideal use for a busy variegated yarn, or a hat design that fits a broad range of head sizes, perfect for gift-giving?

When recently looking for a fun travel knitting project, I came across a pattern for a blanket that I adored…from the picture, it looked like it was made in one piece, which would have

immediately eliminated it for consideration. But the introduction explained that it was worked in squares, each requiring one ball of yarn—making it a perfect travel project. I would have passed it over if the designer hadn't provided that detail in the introduction.

INFORM: Tell me what to expect from the experience.
Tell me what your pattern has and what working your pattern is going to be like.

- Give an overview of the construction, the knitting process: seamed or seamless? Top down or bottom up? Worked flat or in the round? Steeked?

- For items with pattern stitches, does it contain charts or written instructions or both?

- Does it offer different options? For example, does a scarf have a wide and a narrow version; for a garment, short sleeves and long sleeves; for a sock, short and long legs?

- Are there suggestions for altering the sizing?

- Have you included tutorials or a detailed explanation of key techniques? Or, equally, do you assume certain skills—such as "assumes knowledge of short-rows." See the Level of Difficulty/Skills Required section below.

- Is there something particular about the style of the instructions? For example, I always write my sock patterns to be "needle-agnostic"—that is, permitting use of DPNs, magic loop, or two circulars—and I note that in the intro.

THINGS YOU CAN DO TO MAKE KNITTERS LOVE YOU

If the pattern requires non-knitting skills such as crochet or embroidery, state that up front.

Don't Just Take It From Me

I would like some schematic/construction information in the pattern blurb on Ravelry that you can see before purchasing. I understand that some of this is "secret sauce," but I want to know if waist shaping is included, how the sleeves are attached, or whether the hat is top down or bottom up.

I really need patterns to spell out construction—please don't assume that I know what set-in sleeves are or that I know how to join them. Any pattern that requires non-knitting skills (sewing, crochet, embroidery, etc.) should have those clearly stated somewhere right at the beginning. Most of my pet peeves are with patterns that assume I'll be willing to develop a completely new skill set on the fly.

ADVICE FROM AN EXPERT: Dyemaster Kim McBrien-Evans

I strongly believe that most of what knitters find difficult is because they have been told it's difficult. Turning heels, cables, picking up stitches, p3togtbl: none of these is particularly difficult to execute, but we're told they are.

I would love to see the industry changing the approach, toward listing skills learned in a pattern, and providing tutorial links/video links/LYS support with the positioning "this might be new for you, but there is support for you here to learn it."

Level of Difficulty & Skills Required

This is a relatively new addition to the list of mandatory pattern items. Magazines have used such designations for some time, but they are less common in books and individually published patterns.

In essence, this is about the designer being able to set some expectations: tell the knitters what you need them to be able to do to successfully work the pattern. Think of it as letting knitters know what they are getting themselves into.

There are two schools of thought on how to present it: as a difficulty level, or as a list of skills required or techniques used.

A difficulty-level rating (e.g., beginner, intermediate, advanced) is more concise and easier to present, but can lead to issues. Knitters aren't necessarily very good at assessing their own skill level. Heck, very few practitioners of anything are. I have met knitters of twenty (or more) years' experience who knit socks and intricate cable patterns, yet routinely say that they're "not very good" because they don't do lace. And newer knitters often overestimate their abilities... it's the "unknown unknowns" problem. There's also a subtle judgment about this sort of presentation: "Oh, I don't know, I'm not smart enough for that pattern," or "I'm not a beginner, why would I want to knit that?"

Using a difficulty level rating creates a challenge for the designer, too: how to decide what level the pattern is. It's true that working stockinette stitch in the round on a circular needle is easy, but not if you've not done it before. And the knitting of stockinette on a circular is easy—I could hand needles with a joined round to a beginner and they could do it—but remember that joining the round is trickier. And designers, often being relatively skilled knitters themselves, are generally pretty terrible at estimating how hard a pattern is to make. The publications that use difficulty levels do provide some kind of guideline for the categorizations, but they're often pretty vague. One major publisher defines Intermediate as, "For knitters with some experience. More intricate stitches, shaping and finishing."

Knitty.com takes a slightly different approach. Rather than phrasing it as a "skill" level, it's about "challenge" level. There's Mellow, Tangy, Piquant, and Extra-Spicy. These designations very deliberately don't say anything about the knitter, but rather about the pattern. And the explanations of these levels is keyed to this, too: Mellow is described as being a pattern that's "relaxing" to knit, Piquant patterns are "probably not TV knitting."

A "skills required" list takes more space, but is less ambiguous, and can be more helpful.

Make the list detailed, but don't go overboard. You can safely assume any knitter knows how to knit and purl and cast on and bind off. Although that having been said, if the pattern is a tutorial-style pattern for an absolute beginner knitter, state that clearly in the introduction!

> **Pattern requires the following skills: knitting in the round on a circular needle, increasing, decreasing, working ribbing.**
>
> **Pattern requires knowledge of seaming.**
>
> **Pattern uses the following techniques: working lace from a chart, Japanese short rows, grafting.**

And this permits a way to broaden your audience: don't be afraid to use "advanced" or "special" techniques, and list their use, but provide tutorials and references. For example:

> **Pattern uses both placed and strung beading techniques, and a detailed tutorial is provided so no prior beading experience is necessary.**

I learned an important lesson with a lace pattern. It wasn't difficult to work, but because of the nature of the pattern stitch, I had only provided a chart. I'd made no statement about skill required, and I received a lot of question and comments from knitters who were intimidated by the chart. In some cases, they were pretty upset. I added a clear statement up front that you needed to have chart-reading skills. I narrowed the audience

for the pattern, but gained proportionately significantly more happy knitters.

A few months later, I made a second update to the pattern: I created a tutorial for reading the chart. I removed "chart reading" from the "skills required" list and added a note that the pattern uses charts, but a tutorial is provided. This not only broadened my target audience, it actually attracted more knitters to my pattern—I was able to promote it as a great way to learn charts.

No matter how you present it, some kind of statement of expectations is only going to lead to more successful and happier knitters.

Materials & Equipment Lists

Yarn

All the following details should be given:

- **Yarn manufacturer and name of yarn**
- **Fiber content**
- **Yardage and put-up (i.e., size of ball/skein)**
- **Required number of balls/skeins, or total yardage, for each size**
- **Color name(s)/number(s) used in the sample**

For example:

> **Fancy Yarns 'Magic Merino' (100% superwash merino, 175 m per 100 g skein); 10 (11, 11, 12) skeins; sample uses color "Very nice blue."**

Older patterns often specified yarn usage by weight/mass (e.g., 10 two-ounce balls), and some international patterns still do. The issue with this is that different fibers weigh different amounts, and so it's not an accurate measurement of length. As an example, compare three yarns of equivalent put-ups and thicknesses: Berroco Comfort is an acrylic and nylon blend, Paton's Canadiana is 100% acrylic, and Cascade 220 is 100% wool. Each comes in a 3.5 ounce/100 gram skein. Comfort has 197 yards (180 meters) in 3.5 ounces, Canadiana has 205 yards (187 meters), and Cascade 220 has 220 yards (201 meters). Ten skeins of Comfort or Canadiana

BECOMING A BETTER PATTERN WRITER: Go Work in a Yarn Shop

It's very illuminating to talk to actual knitters—the audience for your patterns. The questions they ask are the questions you should be attempting to answer in your patterns: "I can't find this yarn, can you suggest another that would work?" and, "How do I know if this hat is going to fit me?" and, "Is this pattern difficult? I've never made a sweater before."

Selling patterns in a shop also makes it very clear what appeals: what types of projects, what types of presentations, what level of challenge knitters are seeking.

THINGS YOU CAN DO TO MAKE KNITTERS LOVE YOU

For a shawl, wrap, or scarf, provide milestones for yarn usage. That is, give the knitter a sense of how much yarn they should expect to use for each section so that if they are modifying the piece, or using a different yarn, they can keep track of their progress and ensure they have enough yarn.

I'm hard-pressed to think of a yarn company that has more different lines of yarn, each with "Cascade" in the name... This is missing the specific name of the yarn used (not to mention the remaining details).

Improvement: Specify the yarn name, weight, and length per skein, hank, or ball.

wouldn't provide sufficient yardage to substitute for ten skeins of Cascade 220.

Aiding Substitutions

You'll make your knitters happy if you also provide information about the yarn, to aid substitution. Details on coloring: Solid? Semisolid? Long stretches of changing colors? Short stretches of changing colors? Self-striping? Wildly variegated? If the pattern really only looks good in a solid or semisolid colorway, state that. Equally, if the pattern is a great way to use up a busy variegated yarn, or looks boring in a solid yarn, say that, too!

Details on texture and composition of yarn: Smooth? Tightly twisted? Lofty? Slubby? Slippery? Grippy? If you need a non-superwash wool for felting or steeking, make that clear.

This kind of information is particularly important to include if the yarn used in the sample is not broadly available. And even broadly available yarns get discontinued.

Consider also including some sort of indication of the thickness/weight of the yarn, for example:

> **Look for a fingering-weight yarn that knits to 30 stitches in 4 inches (10 centimeters) on US# 1-2 (2.25-2.75 mm) needles.**

Although the gauge information does often communicate yarn type, it's not always a clear indicator: if the pattern uses a different-size needle than you might normally for a specific effect (for example, working a fine yarn with large needles for a lace shawl), or if the piece is worked in a pattern stitch with a very different gauge (e.g., lace or cables). See the Gauge section for more discussion on this.

And consider skein size, too, as it relates to substitution: If the project uses only a fraction of a full ball/skein, state that. For example, a hat calling for fingering-weight yarn might use less than half of a 400-yard (365-meter) skein. Including this information helps knitters make informed substitutions. Without that info, a knitter might buy two 50 gram/200 yard (183 meter) skeins, when only one is required. Including this kind of information might also enable use of leftovers—which can be a selling point for a pattern!

For colorwork projects, or projects requiring small quantities of yarn for edgings or trim or stripes or the like, be clear about the quantity used and scope for substitution. A pattern that requires purchase of a $30 skein of yarn for a single row of contrasting color edging isn't very knitter-friendly.

Don't Just Take It From Me

I would like more yarn guidance. All kinds of knitters are going to be using a pattern; maybe we won't be knitting with the yarn used in the design because we live in another country, are knitting from our stash, or have a small budget. I would like to see help for yarn substitutions such as:

1. Standard yarn-weight information, using Craft Yarn Council Yarn Standards or some other descriptive name.

2. Recommendation on the type of yarn if it's important to the execution of the pattern. Does it need elasticity or strength? Should it bloom when blocked or have a certain amount of drape?

3. Additional gauge information. Is the yarn being used at an unusual gauge to achieve a particular effect in the garment?

I love when a pattern states the yarn used and then, for substitution purposes, details the spin, weight, and fiber content.

If you only need ten yards, state that, and provide information that might help the knitter to use up stash leftovers, as in:

Only 10 yards (9 meters) are needed for the contrasting color bind-off. You can use another yarn, as long as it's a similar texture and weight.

Needles

Needle size, type and length, as required, as in:

4.5 mm/U.S. size 7 needles.

> **Dangerous Assumption Alert:** If the needle type isn't given, we generally assume that straight needles are needed—or at least needles for working flat. If you don't specify needle type, be sure it's because you mean needles for working flat!

Many knitters also use a circular needle to work flat. Consider the formulation:

4.5 mm/U.S. size 7 needles for working flat.

Or even:

4.5 mm/U.S. size 7 needles for working flat: straight or circular as you prefer.

If the piece is worked in the round on a circular needle, specify the length required, as in:

4.5 mm/U.S. size 7 24-inch/60 cm circular needle.

Consider the availability of the size you're asking for—16-, 24-, 32-, and 40-inch (40-, 60-, 80-, and 100-centimeter) lengths are common, but 8-, 9-, 12-, 20-, and 60-inch (20-, 23-, 30-, 50-, and 150 centimeter) lengths can be harder to find. Better to ask for more readily available sizes, or suggest an alternative, as in:

4.5 mm/U.S. size 7 20-inch/50 cm or 24-inch/60 cm circular needle.

And if the piece is a small circumference in the round—such as a sock, mitten, sleeve cuff, or hat crown—consider your strategy: are you going to be specific about the needles required, or are you going to be needle agnostic? These pieces would

Don't Just Take It From Me

I like to see the materials that will make up the knitted piece listed together (e.g., yarn, buttons, zippers, etc.), and the tools used in the making of it listed separately (needles, markers, cable needle, etc.). Seems to make organizational sense to me.

have traditionally required DPNs, but are often now worked with the magic-loop method, or using two circulars, or even using those little 8- and 9-inch (20- and 23-centimeter) circulars. (See page 60, Working in the Round.)

4.5 mm/U.S. size 7 needles for working a small circumference in the round: DPNs, 1 long circular, or 2 short circulars.

And if you're asking for DPNs, don't ask for five unless you're actually using the fifth needle. Many DPNs come in sets of four. I once bought a new set of DPNs because the pattern told me I needed a set of five and I only had a set of four at home. It turned out, though, that when I started working the pattern, only four were actually used. I was annoyed at the waste of money.

Don't forget to include all the needles required for the project. Is a smaller size used for the cuff? A spare for a special cast-on or three-needle bind-off? And for a hat, it's usually a 16-inch (40.5-centimeter) circular and then needles for a small circumference—those second ones are often forgotten, since they're only used for a small portion of the project.

And if you suggest, for example, to use a larger needle for the bind-off, don't forget to list that larger needle in the materials list.

Imagine that your knitter is using the materials list to pack their suitcase for vacation knitting. Make sure it's absolutely complete. You don't want them to be stuck on a cruise ship without the tools required.

Table of Needle Sizes

METRIC SIZE	U.S. SIZE	U.K./CANADIAN SIZE
1.5 mm	000	No standard equivalent
1.75 mm	00	No standard equivalent
2 mm	0	14
2.25 mm	1	13
2.5 mm	No standard equivalent; some patterns list as 1.5	No standard equivalent
2.75 mm	2	12
3 mm	No standard equivalent; some patterns list as 2.5	11
3.25 mm	3	10
3.5 mm	4	No standard equivalent
3.75 mm	5	9
4 mm	6	8
4.5 mm	7	7
5 mm	8	6
5.5 mm	9	5
6 mm	10	4
6.5 mm	10½	3
7 mm	No standard equivalent; some patterns list as 10¾	2
7.5 mm	No standard equivalent	1
8 mm	11	0
9 mm	13	00
10 mm	15	000
12 mm	17 (sometimes)	No standard equivalent
12.75 mm	17 (sometimes)	No standard equivalent
15 mm	19	No standard equivalent
19 mm	35	No standard equivalent
20 mm	36	No standard equivalent
25 mm	50	No standard equivalent

INCLUDING METRIC NEEDLE SIZES IS MANDATORY

They are clear, unambiguous, understood internationally, and precise. Other sizing systems have gaps. Other sizing systems aren't easily distinguished. If I say "size 6", is that a U.K. or a U.S. size 6? If you're buying needles outside of the U.S., you might not even be able to find the U.S. sizes listed. So yes, metric measurements are required.

If you do include a non-metric size, identify it fully and clearly, as in "U.S. size 7," "U.K. size 3."

I saw a knitter led horribly astray by a pattern that simply asked for "size 4" needles. She started with metric 4 mm; the yarn shop she asked for help thought it might have been U.S. size 4. Turns out it was neither: the pattern was published in the U.K. and was calling for a U.K. size 4, which is actually a 6 mm needle. For any size number given, make

sure it's clear what numbering system it belongs to: 6 mm? U.S. size 6? U.K. size 6?

Some metric sizes don't have U.S. equivalents, which can lead to trouble. My favorite 2.5 mm size for sock knitting, has no U.S. equivalent. You sometimes see its conversion given as U.S. size 1, 1.5, or even 2. If there is no U.S. equivalent, don't guess or make one up or go with the nearest; just list the metric size alone.

A designer recently told me a story about a magazine that converted her metric needle sizes to U.S. sizes. Because there is no equivalent U.S. size, they converted a 7 mm needle to a U.S. size 10.5—which isn't the same size. No wonder knitters are having trouble matching her gauge.

"OR SIZE REQUIRED TO GET GAUGE?"

I wish we didn't need this phrase... It's not mandatory, by any means, but it won't do any harm to include it. Take it as an educational opportunity! Remind the knitter that the needle size given is merely a recommendation. Indeed, many designers and publications use "Recommended Needle Size" as the title of this section. I've also seen a pattern that didn't give any size at all, and just stated "needles for working in the round that give the gauge below." This would be okay for experienced knitters, but it's helpful to knitters—especially less-experienced ones—to know what size to use to start their swatching; they can adjust from there as needed.

Notions

These things are too easy to forget, which is very annoying for the knitter. There's nothing worse than only discovering you need a stitch marker at 11 p.m. on a Sunday night when you're away from home and don't have your full kit.

- Stitch markers. (Removable? Several of different styles or sizes or colors?)

- Stitch holders?

- Cable needle?

- Crochet hook? What size?

- Length of contrasting-color waste yarn for stitch holder/provisional cast-on?

ON THE U.S. STANDARD NUMBERING SYSTEM

In recent years, U.S. publishers and yarn companies have started to use a new yarn categorization system: numbers.

 33–40 sts over 4 inches (10 cm) in Stockinette Stitch

 27–32 sts over 4 inches (10 cm) in Stockinette Stitch

 23–26 sts over 4 inches (10 cm) in Stockinette Stitch

 21–24 sts over 4 inches (10 cm) in Stockinette Stitch

 21–24 sts over 4 inches (10 cm) in Stockinette Stitch

 12–15 sts over 4 inches (10cm) in Stockinette Stitch

 6–11 sts over 4 inches (10 cm) in Stockinette Stitch

The objective is excellent: to provide a way for yarn manufacturers and designers to identify the weight/thickness of a yarn. Some publishers and designers are including these symbols in patterns as an adjunct to gauge, to aid knitters in finding yarn.

There is a small drawback, however: each category represents a range of gauges (some of them surprisingly broad), and therefore isn't precise enough on its own for a pattern. These designations can be useful to include to help the knitter shop—they get her to the right section of the yarn shop—but you still need to specify the actual gauge.

Information courtesy of the Craft Yarn Council

- Buttons?

- Zippers?

- Pom-pom maker?

Scissors, Tape Measure & Yarn Needle?

In general, these aren't included in the materials list, as it's pretty safe to assume that a knitter has them as part of their standard kit. It's entirely up to you if you include them, just be consistent. I only include them in patterns targeted at absolute beginners.

Gauge

The complete listing provides all these details: number of stitches and rows/rounds in pattern stitch over 4 inches (10 centimeters), with needles of a particular size:

> **20 stitches and 28 rows in St st over 4 inches (10 centimeters) on 4.5 mm (U.S. #7) needles.**
>
> **26 sts and 28 rows in cable pattern over 4 inches (10 centimeters) on 4.5 mm (U.S. #7) needles.**

..

It is never, ever true that gauge "doesn't matter."

..

Gauge is predominantly about size. To create a piece that is the size indicated, the knitter must knit to gauge.

But many knitters don't realize that gauge matters even if size doesn't. To create a piece with a fabric that matches that shown in the photographs, the knitter must knit to gauge. For a piece such as a shawl or a scarf, where drape matters, too tight a gauge takes the drape out; too loose and you lose stitch definition.

And gauge matters for yarn usage. Knitting too loosely uses up more yarn. What might have been sold as a one-skein project might require a second skein for a looser knitter. This is precisely the sort of thing that makes knitters cranky.

Knitters (those who swatch, anyway) are in the habit of matching stitch gauge, and worrying a little less about row/round gauge. It seems to be much easier to match the former than the latter. If row/round gauge matters a lot for your pattern, it's worth stating that.

Don't Just Take It From Me

What I really hate is when the pattern information only includes the gauge "in pattern." This makes it very hard to know if I have a good substitute yarn when I don't have the original yarn on hand.

I want granular information about gauge. List it for all stitch patterns, including width and depth measurements for cable panels, and provide gauge in a stockinette swatch.

Remember that gauge is also a guide to finding the right yarn for a pattern. Yarns get discontinued all the time, and accurate and complete gauge information helps knitters find a substitute.

There are patterns where it is genuinely not critical to match gauge for the finished result: a blanket that you're donating to an animal shelter, a bag that's going to be felted, a dishcloth. It's perfectly okay to state that, but always give the gauge information anyway—it's about so much more than size.

"Take Time to Check Gauge."

This is one of those statements that pattern writers shouldn't *need to include* in their patterns. It's entirely up to your own personal style if you wish to include some kind of statement like this

DON'T DO THIS

I once saw a pattern that stated the gauge as "Meh." This says two things about this pattern: that a knitter is given no clue or guidance for how to reproduce the fabric as shown in the project photos, and that the designer couldn't be bothered to properly document the pattern. What's the opposite of "inspiring confidence?"

with the gauge information. It certainly doesn't do any harm. There can be a larger educational opportunity here: If there's something unusual about the gauge— if it's measured over a pattern stitch, or if you're deliberately working the yarn more tightly or loosely than normal —then provide tips on how to swatch for gauge, how many stitches to cast on, how many repeats to work, etc.

Giving Gauge in Stockinette Stitch

For a piece worked only or mostly in stockinette stitch—say, a sweater with ribbed edgings— providing only stockinette gauge is fine; you don't need to also include ribbing gauge.

Giving Gauge In Pattern Stitch

For a piece that has significant sections worked in other pattern stitches as well, give gauge in stockinette stitch and the pattern stitch(es) used.

> The charted cable motif measures 3½ inches (9 centimeters) across and 4 inches (10 centimeters) high, after blocking.

For a piece that's worked entirely in a pattern stitch, it's very helpful to give gauge in both pattern stitch and stockinette stitch anyway, to aid yarn substitution. Just telling a knitter that they need a yarn that works to 26 sts in 4 inches (10 centimeters) in a cable pattern, for example, doesn't help them find and buy the right yarn. Gauges for pattern stitches can be very different than gauge for a yarn worked in stockinette stitch, and so you can't draw any conclusions about the yarn from only that information. Think of it this way: stockinette gauge gets you into the right section of the yarn shop, and gets you the right yarn; pattern-stitch gauge gives you the right needles and the right finished result.

This is a point of lively debate: Not all designers feel it's necessary to provide the stockinette gauge if stockinette is not used in the pattern. After all, it's not actually necessary to check this gauge and they don't want to imply that it's required. (I suspect the fear is that a knitter who is disinclined to swatch will be even further

discouraged if they feel that two swatches might be required. This isn't unreasonable.)

Another way to provide this sort of yarn-shopping support is to make a note about the yarn weight and stockinette gauge of the yarn used in the materials list, for example:

> Note: The yarn used for this pattern is a worsted weight that works to 20 stitches in 4 inches (10 centimeters) on a U.S.# 6–8 (4–5 mm) needle.

And of course, providing one of the U.S.-standard "category" numbers can also provide some guidance here, but these categories are broad, and aren't necessarily very useful.

Further Considerations

Rows or rounds? Be clear about whether the gauge was measured on a piece worked flat or in the round.

Which needles? If the pattern calls for more than one needle size, be clear about which size should used for the gauge swatch.

After blocking? For a fabric that changes radically with blocking—typically, lace— make it clear that measurements are taken after blocking.

All measurements should be given after blocking. Since different fibers can behave radically differently after blocking, a pre-blocking measurement isn't particularly meaningful or helpful. If the pattern is for less-experienced knitters, it might be worth reminding them of this.

Over 4 inches (10 centimeters). Some patterns provide gauge over 1 or 2 inches (3.5–5 centimeters), but you should always provide gauge over 4 inches. It's a rounding issue—it's pretty hard to count fractions of stitches, so you get a more accurate count over 4 inches than over fewer than 4 inches. For finer yarns—fingering or lace weight—providing gauge over 2 inches is okay, but knitters can get into trouble with this. The majority of ball bands and patterns provide gauge over

4 inches, and a reading error could lead to substitution mistakes. Imagine a pattern that calls for a yarn that works to 7 stitches over 1 inch being worked with a yarn that works to 7 stitches in 4 inches. That's going to be an awfully strange sock.

Size, Measurements & Schematics

There's a lot of confusion about sizing information as it's usually presented. A surprising (or perhaps not surprising) proportion of knitters don't really get the significance of—and the difference between—an item's size and its finished measurements. And even if they do understand it, they often make poor decisions about what size to make. The more information you can provide about size and measurements, the more successful and happy your knitters are going to be.

Traditionally, a pattern would have provided first and foremost a Size. This was intended to tell you how many sizes are in the pattern, and to provide an indication of whom (or how) the item is supposed to fit—such as Men's S, M, L.

The problem is that size alone isn't helpful when it comes to deciding which size to make, especially when it's presented in such vague terms.

Even if the sizes are given as measurements, as in:

> Size: to fit 34 (36, 38)" [86.5 (91.5, 96.5) cm] chest

That doesn't actually tell the knitter much about the garment.

You need to provide two sets of information: *size* (some kind of indication of whom [or how] the item is intended to fit) and *finished measurements* of the item (the dimensions of the finished knitted piece).

The finished measurements are actually more important than the relative size. I really can't determine if a garment is going to fit me to my liking if you don't tell me how big it is, and it's possible that I like my hats more fitted than you do because I have very short hair. Providing finished measurements also helps the knitter determine if

alterations are required, and makes it a little easier to make those alterations.

Remember that all finished measurements should be given *after blocking*. Since different fibers can behave radically differently after blocking, a pre-blocking measurement isn't particularly meaningful or helpful. If the pattern is for less experienced knitters, it might be worth reminding them of this.

The two sets of numbers can be presented together, as in:

Size & Measurements:

> One Size—scarf is 70 inches (178 centimeters) long and 10 inches (25.5 centimeters) wide.

Or as:

Size & Measurements:

> Baby Blanket version: 30 × 36 inches (76 × 91.5 centimeters)

> Afghan version: 45 × 50 inches (114.5 × 127 centimeters).

They can also be presented separately:

SIZES:

> Adult S (M, L).

FINISHED MEASUREMENTS:

> Circumference: 19 (21, 23)" [48.5 (53.5, 58.5) cm] around lower edge.

> Depth: 8 (8.5, 9)" [20.5 (21.5, 23) cm], not including earflaps.

Not everyone is shaped like a **Vogue** model. It would be lovely if patterns would include a generous range of sizes and at least provide hints for altering the pattern to make it larger/smaller or longer/shorter when how to do so isn't obvious.

The Size

"Size" should tell you the dimensions of the person or thing you intend the item to fit.

This isn't always required, of course. If it's a "non-fitting" item such as a scarf or blanket, there's no need to make any statements about whom or what it's supposed to fit. But do always make it clear how many versions there are, and give some sense of why the options are there, as in:

- One size
- Two sizes—a kerchief and full shawl
- Newborn (baby, toddler)
- Adult S (M, L)
- Men's Small and Large
- Women's XS (S, M, L, XL, 1X, 2X)

I'm not a fan of using numeric measurements for sizes, as they can confuse. If a pattern says that the sweater is a "34-inch (86.5-centimeter) chest size," many would read that to mean that the chest of the sweater measures 34 inches. This may or may not be true. Save your knitters the confusion.

And please avoid using generic terms such as "small, medium, and large" without context. Although it might be clear for a woman's garment, for items such as hats and mitts, it's potentially ambiguous. (Particularly because we can look at finished measurements for a garment and get a pretty good sense of what size person it might fit, but people have a much harder time guessing what size/age a 7-inch [18-centimeter] circumference mitten would suit.)

Better to give some context to clarify the size range, as in:

- **Adult Small (Medium, Large)**
- **Teen (Woman's Average, Man's Average)**

Think of the size indicators as the names of the different versions of the pattern, as the way you're going to be able to distinguish between them.

And if you don't have them, that's fine, too. If you need to refer to relative sizes and you only provide finished measurements, you can always say "first size" and "second size."

GUIDANCE ON CHOOSING A SIZE

If the item is a piece of clothing or "fitting" accessory (e.g., a mitten versus a scarf), you will add an enormous amount of value to the pattern—and radically increase knitters' chance of success—if you provide guidance on how to choose which size to make.

(Indeed, this solves the problem from above about the "34-inch (86.5-centimeter) chest size" sweater.)

You might express this in terms of ease, as in:

> **Garment is close-fitting. Choose a size no more than a couple of inches larger than your actual measurements.**

> **For socks, choose a size with about 1 inch (2.5 centimeters) of negative ease.**

> **Choose the mitten size closest to your actual palm circumference.**

Or in terms of measurements:

> **For teapots 12 to 14 inches (30.5–35.5 centimeters) in circumference (not including the handle or spout), make size Small. For teapots 14 to 16 inches (35.5–40.5 centimeters) in circumference, make size Large.**

Or in terms of available yarn or desired outcome:

> **If your skein of laceweight is between 600 and 800 yd, (549–732 m)work the smaller size; if you've got at least 850 yd (777 m), you've got enough to make the larger size.**

And sometimes, it's a simple as a table:

HEAD CIRCUMFERENCE		
20" (51 cm)	22" (56 cm)	24"(61 cm)
FINISHED HAT CIRCUMFERENCE		
18" (45.5 cm)	20" (51 cm)	22" (56 cm)

ONE SIZE FITS ALL

No. No it doesn't.

There are items for which there might only be one size—a blanket, a scarf, a pillow cover, a teapot. That's fine! But these items aren't "to fit." There is a huge range of sizes and shapes and people, and there are no items for which a single size could be described to fit everyone.

Even for something as simple as fingerless mitts, adult women's palm circumferences can vary from 7 to 9 inches (18–23 centimeters). To say that one size will work equally well on all those hands isn't fair—you're asking the same size piece of fabric to accommodate a 30 percent spread of sizes. It's obvious that if you fit to the smallest size, it will be stretched out and tight on the larger size; if you fit to the largest size, it will be far too loose on the smallest size. But even if you fit to the middle, you're going to end up with a piece that looks different on different hands, and simply doesn't fit well on some. A ribbing pattern will be too stretched out on the larger hand, and not stretched out enough on a smaller hand. It won't look like it does in the photos. And as I covered in the Photographs section, the item "not looking like it does in the photos" is the source of a lot of knitter unhappiness.

If it's one size, say it's One Size. Just don't say it "fits."

The Measurements

This section should provide the details on the dimensions of the finished (yes, blocked) item. This is sometimes known as "Actual."

The measurements provided should be sufficient to allow the knitter to decide what size to make. Here are the dimensions you should provide for a variety of project types:

THINGS YOU CAN DO TO MAKE KNITTERS LOVE YOU

For a garment, indicate what size the model is wearing and give his/her measurements, or indicate how the garment is being worn—that is, with how much ease.

Blanket, Scarf, Rectangular Shawl, Rug, Pillow Cover, Wall Hanging:

Length and width.

Hat, Headband:

Circumference around brim/lower edge.

Depth: for hats, from crown to lower edge—indicate whether this measurement includes any earflaps or other dangly bits.

Mittens, Fingerless Mitts, Gloves:

Palm circumference.

Length from tip/top edge to wrist (for gloves, this is length from start of fingers to wrist).

Nice to have, but not critical: cuff length.

Socks:

Foot and ankle circumference (if these are the same, make that clear; foot measurement for a sock is taken around the ball of the foot).

Leg and foot lengths (if fixed, provide the measurement; if adjustable to fit, state that).

Leg Warmers:

Circumference at widest part, circumference at top, circumference at bottom.

Length.

Triangular Shawl:

Width along widest edge, depth at longest point.

Circular Shawl:

Diameter.

Sweater, Cardigan, Shrug, Jacket, Vest, Dress:

> At minimum: width or circumference just under arm, sleeve length from shoulder, body length from shoulder.

> Make it better: shoulder and back neck width, armhole depth, body length from armhole to lower edge, sleeve circumference at top and cuff, sleeve length from underarm.

> Best of all: shoulder and back neck width broken down into individual measurements, length of body ribbing, length of sleeve cuff, depth of neckline (front and back as required, if they are different depths).

Skirt, Shorts, Pants, Soaker, Leggings:

> Waist circumference, hip circumference, length.

> As required: seat depth.

Dog Sweater:

> Length, chest circumference, neck opening.

Other Sorts of Things:
Whatever measurements are important to the structure of the item, to allow the knitter to figure out if it's going to work for its intended purpose, for example:

> Teddy bear: height and chest circumference (is it big enough to cuddle?).

> Tea cozy, mug cozy: circumference, height.

> Belt: length and width.

> Wall hanging: length and width.

> Cat toy: length and width.

Just make clear where the measurements are taken from, as in:

> Christmas stocking: length of leg from top of cuff to bottom of heel.

This is where a schematic is useful.

Don't Just Take It From Me

I like to see lots of measurements for each piece. And good pictures of the front, back, and sleeves.

WHAT IF IT'S KNIT TO FIT?

Some items—such as sock legs, the body of a top-down sweater, mitten cuffs, scarves—really don't need to be a specific size or length. You may wish to leave some dimensions at the discretion of the knitter. That's perfectly fine, but make sure it's clear in your instructions, and if it's likely to affect yarn requirements, make that clear, too. And clearly state the measurements of the sample as shown, as in:

> **Sock leg:** work until sock leg is desired length. Sample shown measures 7 inches (18 centimeters) from top of cuff to top of heel.

> **Work until scarf is length you want.**

But also, as required, add a note to the sizing and/or yarn requirements information, as in:

> **One size:** 10 inches (25.5 centimeters) wide; knit to desired length. Scarf shown measures 60 inches (152.5 centimeters) long.

> **Note:** To make the scarf more than about 65 inches (165 centimeters) long, you'll need another skein of yarn.

And if it's a garment, or item where fit can matter, consider giving recommended lengths, as in:

> Work until sleeve is desired length. For a cap sleeve, work for half an inch (1.3 centimeters) from underarm; for an elbow-length sleeve, stop when it measures 12 inches (30.5 centimeters) from underarm; for a full-length sleeve, work until it measures 17 (17.5, 18, 18.5)" [43 (44.5, 45.5, 47) cm] from underarm, or 1 inch (2.5 centimeters) short of desired full length.

METRIC, TOO?

The U.S. is the only major country left in the world that uses the imperial measurement system exclusively. If your audience is only in the U.S., then providing imperial-only measurements is fine. Canada and the U.K. have a casually hybrid sort of system, and you won't cause too much consternation if you work only with imperial measurements.

The rest of the knitting world is pretty much metric, and your pattern will be more globally acceptable if you provide both metric and imperial, but pay attention to readability—too many numbers in a line can be hard to read.

Going metric-only is great for the rest of the world, but can flummox knitters in the United States.

Schematics

If the design is anything other than a very simple shape—e.g., a square, rectangle, or circle—or a very standard shape—e.g., a sock, a fitted beanie-style hat, or a fingerless mitten—include a schematic.

They're absolutely mandatory for garments, but are also very helpful for other types of items with more than a "basic" shape, an unusually shaped shawl, for example. Knitters often look to the schematic for more than just measurement information: particularly if the photographs aren't clear, a schematic might be the only way that a knitter can get a sense of the details of the construction. Even with good photos, it's not always evident that there's waist shaping in a sweater, for example. And a schematic can be an excellent support for the instructions, providing a map of piece being worked.

Label all the key measurements (see above) for all sizes. If you're using both metric and imperial units, give both measurements.

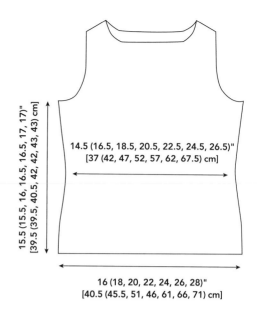

The measurements are the actual dimensions of the finished pieces as shown, after blocking.

That is, if you show the cuff of the sleeve turned up, give the measurement taken with the cuff turned up. Although in a case like this it's also good to show the length of the turned-up cuff.

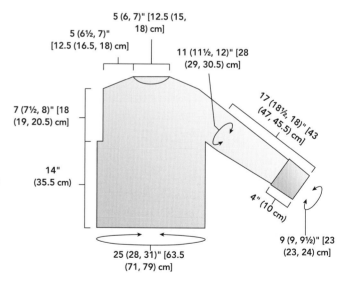

If there are a lot of numbers and sizes, use a letter for each dimension, and provide a table, for example:

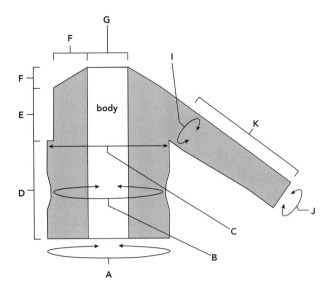

Pay attention to the arrows: make sure they don't "stray" beyond the limits of the piece: there should be no ambiguity about where the measurement is taken. In the first example above, the arrow is the same width/length as the external measurements. The arrow for the waist measurement is placed on the inside of the piece, and it's a little smaller so that the start and end of the arrows are visible.

If it's a piece worked flat, as in the first example above, a straight arrow is perfect, but if the measurement given is for the full circumference,

Don't Just Take It From Me

I always have to modify where the waist shaping is located in a sweater, so I hate when the length between the bottom of the armhole and the waist isn't included in the schematics or measurement info.

I really like schematics with measurements and information on construction—is it top down, knit flat and seamed, etc.?

used a curved arrow, as in the third example above, or as in this hat:

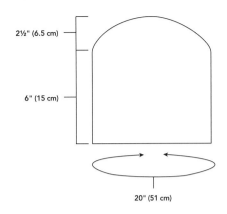

And conversely, if it's a curved line like this, make sure the measurement you give is the full circumference.

The schematic should reflect the shape and proportions of the item. That is, you want to make the schematic look like the item.

If it's a garment worked in one piece, the schematic should show the full garment as one piece.

If it's a garment worked in pieces, show the pieces separately. If a sleeve is worked flat, show it flat/unseamed.

If the sleeves are about waist length, make them waist length on the schematic. And try to match the shape as closely as possible: the knitter is using your schematic as much as a guide to the shape and construction details of the piece as the size.

Make the dimensions proportionate: if the garment is about 10 percent smaller around the waist than around the hips, make the waist of the schematic about 10 percent smaller. If the neckline is about 3 inches (7.5 centimeters) deep on a 9-inch (23-centimeter) armhole, then make sure that your neckline depth is about a third of the armhole depth. Obviously, the proportions will vary somewhat from size to size, but if it's been properly graded, then they shouldn't differ too much. Just pick a size and make the dimensions of the schematic proportionate to that.

Note, though, that if it's a scarf or shawl, for example, where the length is significantly greater

Note, though, that if it's a scarf or shawl, for example, where the length is significantly greater than the width, to show this in proportion would be challenging, but there's room to fudge it. A wiggly line in the middle can be very helpful, for example:

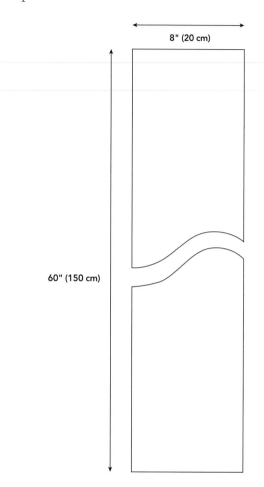

As a Construction or Finishing Aid

You might wish to create a second version of the schematic, without numbers, but with labels. For example, if belt loops need to be attached in a particular position, or you're picking up stitches along one side for an edging, or if you're seaming something together in an unexpected way, a schematic is a very powerful tool.

In this example, a blanket is created from four pieces that are knitted the same way, but oriented differently for seaming. This is much easier to show in a diagram than try to explain.

CREATING SCHEMATICS

Any drawing software can be used to create schematics: Adobe Illustrator is the granddaddy, but it's not cheap and the learning curve is steep. There are free solutions that are very good, such as GIMP, SketchUp, and Inkscape.

I have successfully used the drawing functionality in Microsoft Office applications—a word processor (i.e., MS Word), or even MS PowerPoint.

There is a small drawback to these solutions, however. To get briefly technical: the image you can produce with such software isn't of sufficient quality to scale larger. Purpose-built drawing programs create vector graphics, which can be scaled—enlarged—without losing any quality; Office applications and simpler programs such as MS Paint produce a bitmapped image that is a fixed size, and therefore loses resolution if scaled or printed larger. The trick with using this kind of software, therefore, is to make sure your schematic is big, then scale it down if you need to for inclusion in your pattern layout. Scaling a bitmap image down will not degrade its quality.

Not that familiar with the software? Get a friend to help, outsource it to a professional illustrator, or pay your tech editor to do it.

Including a schematic increases the attractiveness of your pattern, increases the quality of the

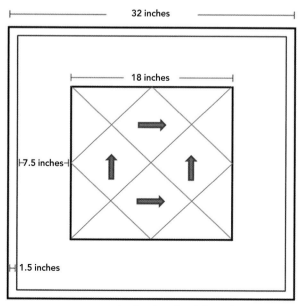

arrows represent the direction of work for each piece

instructions, and increases the knitter's chance of success and happiness with the finished result. The more detail you can provide on how the garment fits, the easier it will be for the knitter to choose the right size to make, and the better fitted the garment will be when it is complete.

If you're submitting to a publication, a scan of a tidy hand-drawn schematic may be sufficient, as it's likely that the publication will redraw it to meet their standard style and format. Check the submission guidelines.

Abbreviations & Glossary, References & Techniques, Pattern Stitches & Charts

These sections are intimately related, and are often combined. Do whatever works for your pattern, but do be sure to include something to address them.

Abbreviations List & Glossary

In a knitting pattern, an abbreviations list isn't really just a list of abbreviations and their definitions.

In a cookbook it's easy: tsp is a teaspoon, tbsp is a tablespoon. The abbreviations are just that: a shortening of words. But in a knitting pattern, to define the abbreviation isn't always enough. Take

w&t for example. Yup, it's an abbreviation: w&t stands for the words *wrap and turn*. But to give that on its own isn't sufficient, because a knitter may not know what the term actually means. How do you actually execute this instruction?

What you really need in your pattern is a hybrid abbreviations list and glossary, with full *explanations* for the abbreviations.

How detailed a list you need depends on the level of your knitter. Do you need to include definitions for *k* and *p*? Likely not.

If you're publishing a full book—or selling digitally—then you'll have room for a list of standard terms and abbreviations and their definitions, and you can be as complete as you wish. If you're paying for printing or just want to save space, then it's expected and accepted that you'll make some educated edits.

Consider the level of your knitter: For a basic pattern, it makes sense to explain k2tog and p2tog. For a more advanced knitter, you can skip those without guilt, but always include the less-commonly used terms.

Be clear where you have specific requirements: If you want the cast-on to be worked in a particular way, state that in the instructions, of course, and it adds a lot of value to the pattern to also give an explanation or reference to one.

There is also the consideration of regional language. Although we're seeing North American standard language become more common worldwide, there are still regional differences in terms, such as *yfwd* versus *yo*, *cast off* versus *bind off*, *tension* versus *gauge*. Again, be aware of the audience you are addressing. For a global audience, it's become fairly common to just provide North American language, but make sure that you define everything well, and provide local equivalents in the glossary. If the pattern is predominantly for a non-U.S. audience, use local terms first.

Some stitches should be defined no matter what the level of knitter you are writing for:

M1, M1R, M1L: Because there are several possible methods that are easily confused, and

you should be clear about what you want the knitter to do.

LLI, RLI: Because they're obscure.

SSK, SSP, SK2PO, S2KPO: Because these are often misunderstood and worked incorrectly.

W&t: Because there are several possible methods, and it's not a commonly known maneuver.

B: K1b is used variously for beaded stitches, for brioche stitches, and for knitting in the back loop.

Some abbreviations should be avoided, in general:

Inc: this is not a specific increase. Sure, if you need to shorten the word "increasing," go ahead, but it's not an instruction. In particular "inc in the next stitch" or "inc at each end of the next row" can cause confusion and trouble, because there are two different types of increases that work two different ways. See The Problem with Inc and Kfb on page 50.

Dec: can be trouble for the same reason. It's slightly less messy than inc, but still lacks specificity.

Made up ones: If a perfectly good abbreviation or name exists for a stitch, you don't need to make up a new one. I saw a pattern once that used "purl2together" instead of p2tog, and I ran across "k2 tog" instead of k2tog, recently.

If you've invented or developed a new stitch—or combined elements in a new way—then it's perfectly okay to make up a new name and abbreviation for it, as long as you check that the name/abbreviation is not already used for something else, and that you define it in the pattern. I'm often doing tricky things with cables, and I recently came up with C4DecPR to describe a four-stitch cable that leans to the right, with purl stitches and a decrease. I defined it clearly, and made sure the knitter could easily find the definition.

See Appendix B: Abbreviations, Standard Terms & Glossary, on page 115 for a master list of commonly used abbreviations and terms in English-language knitting patterns.

Particularly Troublesome Abbreviations & Instructions

EOR AND BOR

I've seen EOR and BOR used in some patterns to indicate "end of round" and "beginning of round" (sometimes for rows, too, but less often).

They aren't bad, but I don't personally find these abbreviations very useful. They aren't phrases you typically use that often in a pattern, so there's no need to abbreviate them. It's worth a few extra characters to make the instruction a bit more friendly, as in:

Place marker for BOR.

versus

Place marker for start of round.

And, most often, the word "end" works just fine, as in:

Rnd 1: [K3, p1] to EOR.

versus

Rnd 1: [K3, p1] to end.

Why create something that the user has to look up in the glossary when an existing word or phrase works just as well? If you do feel you need abbreviations like these, just make sure to define them in your glossary.

SSK

"Slip, slip, knit" is NOT an adequate definition of this stitch. Or a good name for it, either. If you offer that to a newer knitter, the result is likely not a decrease. The knitter slips two stitches and knits a third. (Not to mention that there's no indication as to which direction to slip the stitches.)

The issue with SSK is that spelling out the words in the abbreviation, unfortunately, gives something that looks like an instruction. For example, look at k2tog—you spell out the words and you get the

Don't Just Take It From Me

I hate it when I'm told to "m1" without specifics on how the designer wants that done. There are so many options for how to increase, and I think it's nice to know which one the designer wants me to use. Truth be told, I actually have a favorite method now, which I am inclined to use no matter what the designer suggests, but still, if there's a m1 that is particularly well-suited to the pattern, then let me know!

Please tell me if you want me to slip that stitch knitwise or purlwise!

instruction: knit two together. SSK doesn't work like that. If you spell out the words, you get an instruction that is entirely wrong.

A full definition requires a few more words: slip the next two stitches one-by-one, knitwise[1]; insert the tip of the left needle, from left to right, into the fronts of those two stitches and knit them together. Also good: slip the next two stitches one-by-one, knitwise; return the stitches to the left needle and knit them together through the back loop.

It's actually better to not define SSK than to give the short-shrift definition. If a knitter knows how to do it[2], they don't need the instruction, and if they don't, then you're making them look it up somewhere that will hopefully actually be helpful.

(A noted editor once said to me that she likes to include the "slip, slip, knit" definition, "as it lets knitters know where the abbreviation comes from," but I honestly don't think this is needed. Does it matter what LLI stands for if you know it's an increase, and I tell you how to do it?)

[1] It's becoming more common to slip the second stitch purlwise. This is the knitter's choice. I leave the definition as a knitwise slip for both stitches, as that's the traditional way it's done, and that's how I do it; I might comment on this alternate method if I feel that my knitters might be interested in this (or are able to handle the choice).

[2] Although you'd be surprised by how many knitters do the SSK incorrectly: they get the slips wrong, they put the needle tip in the wrong way.

YO

Yarnover is another troublesome stitch instruction: not only is the name of the stitch an inaccurate description of the maneuver, there are actually a number of different instructions for it, depending on how you knit (English versus Continental versus Portuguese), and how your stitches are set up. Although the end result is the same, there are different ways to get there.

For an English knitter, for example:

A yarnover between two knit stitches: bring the yarn to the front, between the needles, as if to purl.

A yarnover after a knit, before a purl: bring the yarn to the front, between the needles, as if to purl, then wrap the yarn over the needle again, bringing it to the front a second time to be ready for the purl stitch.

A yarnover after a purl, before a knit: leave the yarn where it is, at the front, and knit the next stitch.

A yarnover after a purl, before a purl: wrap the yarn over the needle, from the front over to the back, and around to the front again.

I know skilled knitters who did the yarnover wrong for years, because they were doing what the instruction told them: they were wrapping the yarn over the needle, from back to front, over the top.

The traditional U.K. terms for this stitch—yarn forward (yfwd), yarn over needle (yon) and yarn round/around needle (yrn)—are better, in some ways, because they describe a bit more what's actually happening, and make it clear that the motion differs based on the stitches on either side. I've used them in patterns a couple of times, when I felt the knitters would benefit from this additional information, although when I have I've made sure they are well explained in the glossary.

The downside to using these different terms is that they might be a bit too detailed: if the stitch is only used on a knit fabric, then to be so specific is overkill.

Cable Stitch Format Summary

FORMAT	ALL KNITS	KNITS & PURLS	NOTES
Basic, directional	C#R, C#L	T#R, T#L	Doesn't allow for uneven cables
Basic, working detail	C#B, C#F	T#B, T#F	Doesn't allow for uneven cables
Numbers, directional v1	C#/#R, C#/#L	T#/#R, T#/#L	Suitable for even & uneven
Numbers, directional v2	#/#RC, #/#LC	#/#RT, #/# LT	Suitable for even & uneven
Numbers, working detail	C#/#B, C#/#F	T#/#B, T#/#F	Suitable for even & uneven

Cable Stitch Nomenclature

There are several standards—formal and ad hoc—for naming cable stitches.

I've seen all of the following names used for the same four-stitch right-twisting all-knit cable stitch:

- C4R
- C4B
- C2/2R
- 2/2 RC

And then when you add in purl stitches, there are more options, as in:

- T4R
- T4B
- C2/2PR
- 2/2 RT

There's no absolute right answer for how to name cables—consistency is the main goal.

In general, C is used for a cable stitch that's all knit stitches. T (for "twist") or P (for "purl") is often used when a cable involves both knit and purl stitches, because it's good form to distinguish all-knit cables from those involving purls (e.g., T8B, C8PR, or 4/4 RT).

It's also important to indicate the number of stitches in the cable turn. If it's even—that is, the number of stitches crossed over is the same as the number of stitches under—then simply putting the total number in (e.g., C6L) is clear enough. But

this doesn't work if the number of stitches in the two halves aren't the same—for example, when crossing two stitches over one. The formats Cx/yD or x/y DC are useful here, with D for direction of the cable, (e.g., C2/1R, or 2/1 RC).

You should also indicate the direction of the twist. Some designers prefer to use L and R (left and right), to indicate the direction of the turn, and others prefer to use F and B, to indicate where the held stitches are held—to the front or the back. Either is fine, it's personal preference.

If your cables are all symmetrical, and there are only knitwise cables, then CxR and CxL or CxB and CxF will serve you well.

If there are uneven cables, then better to use the x/y format for all, even the symmetrical ones, as in Cx/xR, Cx/yL, x/y RC, or x/y LC.

If there are purls, either use T or put a P in, as with T4F, C4PL, or 2/2 LT.

It is better to use an abbreviation rather than a full description of the stitch in the pattern rows, as they quickly become unwieldy, for example,

Row 1 (RS): K2, p2, C4R, p2, C4L, p2, k2

is easier to read than

Row 1 (RS): K2, p2, slip next two stitches to cable needle and hold in back of work; k2, then k2 from cable needle, p2, slip next two stitches to cable needle and hold in front of work, k2 then k2 from cable needle, k2.

But no matter what names you use, remember to define them in your glossary or Pattern Notes section. Even if you think it's totally obvious (e.g.,

C4R), define it anyway. Your pattern may be a knitter's first cable project.

Definition format suggestion:

> **Slip next # stitches to cable needle and hold in front/back of work; k# and then k#/p# from cable needle.**

References & Techniques

This section is often combined with the Abbreviations List/Glossary.

It's helpful and valuable to include references and/or detailed technique information for anything that might be beyond the scope of your audience, or anything that's special to your pattern. I always include technique information for something that's not actually knitting—for example, pompoms, tassels, crochet edges.

Consider your list of required skills when you develop this section: If you tell the knitter they need to know the Twisted German CO, you're going to get more knitters working your pattern if you teach them how to do it or give a reference to good instructions, than if you leave it simply as a required skill without explanation.

ONLINE REFERENCES

Laura Nelkin, a designer of beautiful beaded knits, has built a library of tutorials and technique information on her website. Her patterns give descriptions and instructions for the beaded

stitches, and she always points the knitter to her website for further details.

A few caveats: Make sure that the video you link to explains the technique as you want to do it. There are multiple ways of doing some things, for example, wrap & turn, and so make sure that the video you choose shows the technique the way you describe it and do it yourself.

And though it's considered okay to quote small sections—no more than a couple of sentences—of a reference book on a technique, such as instructions for a specific decrease or cast-on, do give full credit and reference to the source.

If you're including a reference to a website in your pattern, make sure you include the URL of the link as well as the live link. If the pattern only contains a live link—such as Visit Kate's website!—those knitters who print out the pattern to work from will not be able to look up the reference.

Visit Kate's website!
http://www.kateatherley.com

Pattern Stitches & Charts

If your pattern uses any kind of pattern stitch (e.g., seed stitch, a complex cable pattern, or a lace stitch), either in written or charted format, then these instructions need to be provided.

Where to put them: Whether they are gathered together in their own section—in the Glossary and

POP QUIZ

How Can This Be Improved?

For better fit, decrease a few sts as you work down the sleeve.

The word **better** is a poor choice here. It seems to be saying that the fit isn't great in the pattern as written. And although well-meaning, this advice is so vague as to be meaningless.

Improvement: Suggest how many stitches to decrease, plus where and how to place them.

Techniques, or included in the flow of the patterns at the relevant point—is a question of personal preference, and ideally is established in your style sheet. See A Personal Style Sheet on page 44 for more discussion of this.

Either way, make the instructions easy to find. (See the next chapter for details.)

Pattern Notes

This is where you gather any "extra" info you might have. Suggestions for creating other versions? Tips on how to resize?

Put them at the start of the pattern, not at the end. Knitters don't always read through the full pattern before they start knitting. To come across instructions at the end of the pattern, say for a different cast-on and edging, or a suggestion for making the lace motif easier to work, or details on how to resize the hat, is just frustrating.

These pattern notes can be part of the selling feature of your pattern. Do you offer alternative versions? Tips on using leftovers?

If it's a broad lace stole that's easily adapted to working on fewer stitches with heavier yarn, include that suggestion. If there are other pattern stitches that could be substituted for the edging worked, list those. Do you have suggestions for adjusting for other figure types? Put all that here.

But instructions that are actually part of the knitting instructions? They don't belong here. I once saw a pattern for a striped cardigan with buttons. The only mention of buttonholes was in the Pattern Notes section, up front:

Notes:

Create the buttonholes on the first row of each stripe, working (yo, k2tog) 3 sts before the end.

Don't Just Take It From Me

For sock patterns with fancy leg designs, I seriously appreciate additional charts or instructions for altering the pattern to fit larger calves.

I want detail about special techniques. Is a special cast-on/bind-off required? Does the finished item require special blocking instructions, etc.?

I don't like having to decide which cast-on/ bind-off or types of increases/decreases to use. Tell me what you recommend!

What I don't like: patterns that spend a good chunk of space describing basics such as how to knit and purl. It's a pattern, not a "how to knit" book.

An instruction like this, one that is key to the making of the garment, needs to be in the actual instructions.

Versions & Variations

There is a fine line here. Obviously, you don't want to be putting a whole new pattern in the Pattern Notes section. If there are two distinct versions of something, photograph them both and create two distinct sets of instructions. I have a pattern that includes a rectangular stole and a semicircular shawl based on the same pattern stitch. I've published them in a single pattern booklet, with a full set of instructions for each version.

On the other hand, I have a pattern for a cabled scarf that uses chunky-weight yarn, and in response to knitter questions, I've put a note in the pattern suggesting how to use the same pattern with finer yarns: how many additional stitches to cast on to be able to work extra repeats of the

cable motif. It's not a full separate pattern because I haven't created a sample or photographed it, and I don't have yarn requirement details worked out, but that note adds value, it adds "re-knitability."

OPTIONAL ELEMENTS

If there's an element that you identify as optional, such as an edging or decorative element, clearly identify whether that element is in the sample as photographed. For example:

> **Optional earflaps: shown in sample as photographed.**

THINGS YOU CAN DO TO MAKE KNITTERS LOVE YOU

Provide tips for altering and guidance on how to modify for different body types. There are many patterns presented as "for women" that could easily be worn by a guy if the pattern were adjusted. Detailed schematics, ease measurements, etc., can help determine how to adjust the pattern regardless of body features.

Don't Just Take It From Me

> It's not an exam! I don't like being told to read the pattern all the way through before starting, even if it's the correct thing to do and I usually do it.

> I don't like assumptions! Let's just assume that I don't know what the hell I'm doing...

> I hate reading through a whole pattern before I start knitting, but I love when each step is spelled out and I don't have to do the math.

> I love it when a pattern starts with an overview, such as: "We will use a tubular cast-on, progress through five different cabling patterns, and use a sewn stretchy cast-off."

BECOMING A BETTER PATTERN WRITER: Look at Knitters' Patterns

It's very educational to look at the patterns—the physical sheets—that knitters are working from. What notes or adjustments have they made? What have they underlined? What have they added? Which page is the most marked-up?

Have they folded a particular page so that a certain section can be easily referred to? Is it an instruction that should go on the main page, or with the glossary?

Have they photocopied and enlarged a chart? Perhaps this means that the chart is too small in its original printed format.

Have they written out the instructions for a particular stitch, such as an increase or decrease? Add it to your glossary.

Have they rewritten the instructions for a complex set of repeats? Perhaps you can break them out and explain them better?

I helped a knitter recently with a cabled sweater pattern. The back had three charts, A, B, and C, which were all printed on the same page. She was having terrible trouble following the charts because of the way they'd been printed: A was on the left, B was in the middle, C was on the right. She'd had to cut them out and reorder them, C on the left, B in the middle, A on the right—positioned in the order in which you read them. Seeing them rearranged that way made it very clear that what might have seemed like a very logical positioning wasn't logical at all for knitting instructions.

Crochet edging: not shown in sample, but you may choose to work this edging if you're using a heavy yarn and are worried about the neckline stretching.

The Instructions

Don't Just Take It From Me

I recently heard a designer say on a podcast that she picks up extra stitches at the underarm to close potential gaps, then decreases the extra stitches away later. Great idea, but why aren't her patterns written that way?

Designers should write patterns the way they actually knit, incorporating all the tips and tricks they use to achieve a really well-crafted finished item.

The objective is to provide instructions that are complete and clear enough that the knitter can reproduce what you did. See the next chapter for details.

Contact Information

- **Your name**
- **Email address**
- **Website/Ravelry shop URL**

Knitters need to know who designed the pattern, they need to know how to get in touch with you if they have questions, and they need to know where to find more of your work so they can buy it. Be sure to include your full name and email address. Ravelry contact information is a nice-to-have,

POP QUIZ

How Can This Be Improved?

Sizes:
Small (medium, large, extra-large).

Note about sizing:
I've only tested the small size, let me know about any problems you find with the others.

This doesn't exactly inspire confidence. If it's a pattern that the designer wanted test knit, that's okay, but that needs to be made clear up front.

There is a very popular pattern on Ravelry that features a note very similar to this. It's not marked this way in the pattern information on the project page, which isn't fair to knitters who are seeking a reliable pattern. And this particular pattern has been available for at least four years; surely the designer has had some feedback by now, and can update the pattern?

but not every knitter uses Ravelry. Email is more universal.

A short bio is a nice addition to a multi-pattern book or booklet.

Credits

List anyone whose work went into the creation of your pattern: tech editors, test knitters, photographers, proofreaders and copy editors, graphic designers.

Copyright Statement

Not actually required, but a very good idea. See page 104, Chapter 8: On Copyright, for information about the wording and significance of the statement.

Date, Version Number

Include the year (if not also the month) that you release the pattern, and a version number—which you will update if you issue a new version—so it's easy for the knitter to identify if they're working from the most recent version of a pattern.

The Actual Knitting Instructions

In This Chapter

To steal a line from the diamond industry, it's all about the three Cs: clarity, consistency, and correctness.

You want the instructions to be easy to understand and easy to follow, and to produce the right thing when a knitter follows them.

There are many different ways of expressing the same thing, all perfectly valid. It's up to you which way you might express a given thing, but you should be consistent in the way that you do it. Consistency in language, in style, and in formatting is incredibly important. Changing midway through a pattern dismays and confuses.

Heading

Indicate the end of the preamble and the start of the instructions with a header, such as "Instructions" or "Method."

Philosophy

Write For Your Knitter

> **Work rev st st for 2 inches (5 centimeters), ending WS row.**
>
> **Cast 68 sts on DPNs. Join in the round and work 2×2 rib for 1 inch (2.5 centimeters).**
>
> **Work 10 rows in St st, decreasing 1 st at each end of every RS row.**

None of these instructions is wrong—in fact, they are all perfectly good. Nor are they outrageously difficult to work. But they all assume knowledge.

You need to know what rev st st is, and which the WS is. You need to know how to work 2×2 rib. You're expected to know how to work St st, how to decrease, and to be able to handle the counting of 10 rows.

Can you expect your knitter to know these things? Think back to your Difficulty Level or Skills Required section. Can you safely assume that your knitter knows this stuff?

For example, execution of the first example is well within the skill set of an utter beginner, but needs more detail to make it accessible.

Rather than

> **Work rev st st for 2 inches (5 centimeters), ending WS row.**

Consider the more explicit

> **Row 1 (RS): Purl.**
> **Row 2 (WS): Knit.**
> **These two rows form Reverse Stockinette Stitch (rev st st). Repeat these two rows for 2 inches (5 centimeters), ending with a WS (Knit) row.**

For the second example, rather than

> **Cast 68 sts on DPNs. Join in the round and work 2×2 rib for 1 inch (2.5 centimeters).**

Consider the more explicit

> **Cast 68 sts onto a single needle. Distribute sts across your needles, and join for working in the round.**
>
> **Ribbing round: [K2, p2] around.**
>
> **Work ribbing as set for 1 inch (2.5 centimeters).**

And to make it even more beginner-friendly, I'd also add a note that when distributing stitches, it's easiest to work if you have a multiple of four stitches on each needle. A less-experienced knitter might be inclined to distribute the stitches perfectly evenly, so that there's the same number on each needle, but in this case, that doesn't work out. (If the knitter is using three DPNs to hold the stitches, then a fully even distribution isn't

possible at all, and if the knitter is using four DPNs, then a fully even distribution would leave the knitter with 17 on each needle, which makes it more challenging to keep track of your ribbing.)

(Note that I've made no statement here about putting a marker in. See Marking the Start of the Round on page 62 for my thoughts on that.)

And for the last example, not only are you expecting that your knitter have certain knowledge, but you're also expecting that your knitter make some decisions:

Work 10 rows in St st, decreasing 1 st at each end of every RS row.

How to decrease? Where to decrease? The newer knitter will use the decrease they know best, likely k2tog. You'll probably see this worked as:

K2tog, k to last 2 sts, k2tog.

A more knowledgeable knitter might know about directional decreases, and so you might see:

SSK, k to last 2 sts, k2tog.

And a really experienced knitter will know that it's better for seaming to work the decreases a couple of stitches in from the edge, so you'd see:

K2, ssk, k to last 4 sts, k2tog, k2.

Or they might even swap them around if they prefer that look, as in:

K2, k2tog, k to last 4 sts, ssk, k2.

These four interpretations of the same instruction are all perfectly valid, but they aren't the same. Does it matter? Depends on your design, of course, but these are details that are subtle but important. Is the piece seamed? The first two versions result in an edge that's more challenging to seam. Seamed or not, the third and forth versions give visible (i.e., "fully fashioned") shaping.

What do you, the designer, want? What did you do, yourself? If you care about how the knitter works the decreases, and where they are to be placed, then be explicit. If the knitter might not know how to work or place the decreases, be explicit. If it makes a difference in the working or the look of the project,

be explicit. Don't assume they'll know what you know; don't assume they'll do what you did.

The Big Picture

There are, in essence, two ways to write instructions: by focusing on the outcome, or by focusing on the steps to get there.

From cooking, you might say:

Caramelize a finely sliced onion

or

Slice 1 medium onion finely.

Heat 1–2 tbsp olive oil over medium heat in a wide, flat-bottomed frying pan.

Spread onion slices in a single layer in pan, and sprinkle with 1 tsp of sugar and 1 tsp of salt.

Let cook for 30 minutes to 1 hour, stirring every few minutes.

FULLY FASHIONED SHAPING

The term "fully fashioned" shaping comes from tailoring, used in the context of machine-made knitwear pieces. Early knitting machines were only able to make rectangles, and so machine-knit fabrics were shaped after the fact, by cutting or seaming the pieces.

Tailors and knitters considered garments constructed from these types of pieces to be of inferior quality. To emphasize their skill and the differences between their work and that of machines, handknitters started working shaping increases and decreases in a manner that is visible in the finished garment—in a manner that wasn't yet possible with a machine—and this was referred to as "fully fashioned" shaping.

As knitting machines became more sophisticated, this type of shaping became possible, and machine-knit garments featured it as often as possible—an industry's attempt to change attitudes about the perceived quality of the work. We sometimes see amusing remnants of this historical bias: machine-knit garments constructed to leave the shaping visible where stylistically it might actually be better to hide it.

They're both perfectly valid, of course. The first instruction assumes knowledge and experience, and the second one is more beginner-friendly.

It's like giving directions to a specific address: Do you tell me where I need to end up, assuming I know how to navigate the city to get there, or do you give me step-by-step, turn-by-turn instructions?

In knitting, you might see an instruction presented like this:

> **Increase at the beginning and end of the next row, and every following 6th row 11 more times.**

But it could also be written like this:

> **Row 1 (RS): K2, M1r, k to last 2 sts, M1l, k2.**
>
> **Work 5 rows even.**
>
> **Repeat the last 6 rows 11 times.**

Again, both perfectly valid. More-experienced knitters often prefer the first, more concise version. There's less to read, there's a clear statement of the desired outcome, and there's an opportunity to apply your own particular skills, knowledge, and preferred techniques. (Apparently, among cooks, there's great debate about the use of sugar when caramelizing onions...)

A detailed row-by-row breakdown, as in the second example above, removes all doubt as to how something is to be done and provides an easy way for knitters to keep track of their progress: they can check off the rows as they go. It seems like a minor point, but it's a crucial one: Think about how the instructions will be used and read. Think about the check marks. If the rows are presented in such a way that the knitter can easily see the repeated phrase or structure, then it's easy for them to keep track, perhaps by placing check marks beside the key rows.

Of course, it's not an either/or situation. You can add a lot of value to step-by-step instructions, support the more experienced knitter, and help a less experienced knitter learn by adding a few words about the objective, the outcome. This way, the details are available for those who want them,

and those who prefer to do it their own way are alerted to what they need to achieve, and which detailed instructions they can ignore.

For our cooking example above, this might be as simple as: "Caramelize onion slices to garnish your pizza, as follows..."

Or, for knitting instructions,

> **Shape the sleeves as follows...**
>
> **Turn the heel, as follows...**
>
> **In this next section, you'll create the neckline by dividing the front into two halves, and working them separately. Note that the neckline shapings for the two sides are the same, but reversed.**

Help the knitter see the big picture! You'll help less-seasoned knitters better understand the pattern and feel confident about their progress; you'll make experienced knitters happier and enable them to apply their only techniques and knowledge, when appropriate. Lots of sock knitters, for example, have a preferred heel turn. Telling them which instructions in your pattern refer to the heel turn allow them to assess if it's one they want to use and let them substitute something else, if they want.

Just make it clear that this note is editorial, not instruction. This type of presentation can confuse:

> **Now, turn the heel.**
>
> **Row 1 (RS): K20, ssk, k1, turn.**

An experienced sock knitter will recognize Row 1 to be a pretty standard heel-turn instruction, and won't second guess. But if this is a knitter's first pair of socks, there's no indication that Row 1 is part of the heel turn. It may well be that you're telling them to turn the heel, and then work Row 1 when it's complete.

The words "as follows," or the phrasing "next, you will..." are very powerful in this situation, to ensure that the knitter understands that you're just describing, not instructing.

> **Now, turn the heel, working as follows:**
>
> **Row 1 (RS): K20, ssk, k1, turn.**

Traditional vs Modern Pattern-Writing Styles

Pattern standards have changed significantly over the years. Even twenty- or thirty-year-old patterns can look very different than patterns published more recently.

"Vintage" patterns tend to be terse, sometimes to an absurd degree. "Modern" patterns tend to be detailed and expansive.

Printing and shipping is expensive and takes time—minimizing the page count of a pattern book could represent a significant cost reduction for pattern distribution.

Because advanced knitting and dressmaking skills used to be more widespread, pattern writers could safely assume more knowledge on the part of the knitter and therefore didn't need to give as much detail in pattern. Cheryl Oberle, in her book *Folk Shawls*, cites a vintage lace shawl pattern that tells the knitter "to cast on about 320 stitches and knit using a lace pattern that had better be simple."

Decades ago, patterns were much less likely to have schematics, diagrams, detailed sizing information, or measurements, and the instructions tended to be pretty generic—the patterns would simply say cast on, increase, decrease, without providing any input or suggestion on how these are best done for that particular piece.

The "modern" environment is entirely different: though some publications are still distributed in print, the cost of printing is no longer a major factor, since the vast majority of patterns are made available online—and indeed many are consumed entirely in a digital manner, on a tablet or computer. (It's becoming fairly common that print publications provide the more condensed version in the book, and then provide downloadable files with expanded details and supporting information.) So for most patterns and purposes, it's the knitter who bears any costs and troubles of printing, and the knitter can choose to print only the pieces she requires, rather than the whole pattern.

WORK VERSUS KNIT

Although in casual language we use "knit" to describe the entire activity and everything it encompasses, using the term casually in a pattern can lead to confusion.

"Knit" is a specific instruction. "Knit 10 rows" gives you garter stitch. If you're talking about anything other than the actual knit stitch, the generic term to use in a pattern is "work."

"Knit 10 rows of stockinette stitch" is both confusing and impossible. Instead, say: "Work 10 rows of stockinette stitch."

Key phrases to keep handy: Work even. Work the last 2 rows. Work in pattern. Work as established.

At the same time, we're dealing with a broader audience: knitters from around the world, from a variety of language backgrounds, and knitters of very different experience levels. Although there are many who could easily deal with an instruction such as "knit using a lace pattern that had better be simple," it's foolish to assume that every knitter has that skill level or has access to a knitter who does.

And let's add into the mix the expansion of knitters' general knowledge about knitting. It would have been much safer to simply say "decrease" fifty years ago than now—an English or North American knitter would likely have known k2tog and p2tog, and maybe SKP, but that was probably it. To ask the knitter to make their own decision about which decrease to use isn't nearly as fraught with risk as it would be for today's knitter, who will be quite comfortable with k2tog, skp, ssk, and k2tog tbl. There are more cast-on methods, increases, and decreases in common use. Decades ago, a pattern published in Eastern Europe would have been designed to use the techniques common in that region, and because it would have only been accessible to knitters in that region, there wouldn't have been an issue. (Not to mention the added detail that a k2tog in a North American pattern might not be the same as a k2tog for an Eastern European pattern, due to regional variations in knitting methods.) Not so now, when online availability makes a pattern published anywhere in the world accessible to anyone at all.

All of this is to say that the current standard for knitting patterns is to be more detailed and expansive than they ever have been—to everyone's benefit. A few extra words don't cost anything more, and can make all the difference between a happy and an unhappy knitter.

A Personal Style Sheet

As you write patterns, I highly recommend creating a personal style sheet. A style sheet is a document that contains a standard list of key structures, definitions, phrasing, language, abbreviations, etc., that you can refer back to and use in all of your patterns. This is by no means a complete list, but here are the sorts of things that you should decide on, and put in your style sheet to apply to every pattern you write:

- Create a master list of abbreviations, including their capitalizations. Do you use *SSK* or *ssk*? *SK2P*, *S2KPO* or *SK2PSSO*? And if it's ssk, what do you do when it's at the start of a sentence—Ssk or SSK?

WHEN SUBMITTING TO A PUBLICATION

Although this is discussed in more detail in Submitting to a Publication on page 93, it's relevant in this context, too. Each publication will have its own standards and standard formations for patterns. A print publication is more likely to prefer a more concise pattern style, but in general, it's better to provide more information rather than less—taking the publication's style sheet into account, of course. In most cases, it's easier for editors to condense something that's too long than it is to flesh out something that's too concise. That being said, if your pattern takes a significant number of pages to express, even before you add any "supporting information" such as schematics, information on specialized techniques, stitch definitions, editors aren't likely to look favorably on it.

- Create a master glossary with stitch definitions. Instead of trying to write out the steps for wrap and turn every single time you use it in a pattern, just copy them from your style sheet. This saves you having to remember how to describe something, and makes sure that your instructions are the same across all patterns.

- If there are phrases you use a lot, write them out once and copy and paste. For example, "Join for working in the round, being careful not to twist." "Block, and weave in ends."

- Do you use the abbreviation *Rnd* or spell it out as *Round*?

- Brackets dividing off different numbers: square or round? How to space them? 1(2, 3) or 1 (2, 3)? 1 (2, 3) or 1 [2, 3]?

- Punctuation and capitalization and how to specify repeats: brackets or *?

- A space between *k* and *p* and the number, or no? k10 or k 10?

- Do you spell out *stitches* or abbreviate to *sts*?

- Punctuation of stitch counts:

 Row 1: K2tog, k to end. 12 sts

 versus

 Row 1: K2tog, k to end—12 sts.

- *Inches* versus *ins* versus " or the format for metric if you're using it: *10cm* versus *10 cm*; *gm* versus *g*.

- There's also a layout section in a style sheet—see Chapter 5: Formatting and Layout on page 82.

These are all expanded on in this chapter.

Keep your style sheet handy so you can refer to it every time you write a pattern. This way, your patterns will be consistent with each other, and you'll save yourself a lot of time.

Of course, if you're submitting to a publication, use that publication's style sheet. See Submitting to a Publication on page 93 for more on this.

Provide A Structure

Use headings throughout your pattern to create a roadmap with milestones, as in:

BACK

Lower Edging

Armhole Shaping

Neckline

This makes it easier for knitters to follow your instructions and keep track of where they are, and it helps them understand where they are in the big picture.

Not to be undervalued: Headings indicate sections, and completion of sections gives the knitter a sense of achievement.

Row Instructions

Punctuation & Capitalization

You need a standard format for expressing row/round instructions. Any of the following choices are valid; pick one you like and stick with it.

Capitalize the row/round name? Use full words or abbreviate?

Row 1? R1? Round 1? Rnd 1?

Capitalize the first instruction of the row/round?

Row 1: Knit.

versus

Row 1: knit.

Capitalize the rest of the instructions in the row/round?

Row 1: K10, p10.

versus

Row 1: K10, P10.

A period at the end?

Don't Just Take It From Me

I love patterns that list the sections (e.g., toe, foot, heel, leg; sweater front, sweater back, etc.), and provide an overview sentence about what's coming next (for example: Next, pick up stitches for the gusset). It helps me better visualize what I'm going to be doing.

ROWS & ROUNDS: Get it right!

If it's a row, call it a row. If it's a round, call it a round.

Row 1: Knit across.

Round 1: Knit to end of round.

I have seen:

Row 1: Knit to end of round.

Is this just a sloppy mistake? This could seriously confuse a newer knitter. Or are you trying to tell me that at this point you want to me start working back and forth in rows? There are patterns that have sections worked in the round and sections worked flat, and this sort of thing can cause confusion.

If there can be any doubt, expand it to be clear, as in:

Row 1 (RS): Knit to end of round. Turn. From here, you'll be working back and forth in rows.

Row 1: Knit.

versus

Row 1: Knit

This one isn't up for debate: Always use a comma to divide up multiple instructions within a row, as in:

Row 1: K10, p10, C8R, p10, k10.

versus

Row 1: K10 p10 C8R p10 k10.

The second is harder to read.

MULTIPLE SIZES

> Repeat Rows 1 & 2 three (four, five, six, seven) more times.

And if you don't do it at all for certain sizes, you have a choice:

> Repeat Rows 1 & 2 four (three, two, one, zero) more times.

> Repeat Rows 1 & 2 four (three, two, one, -) more times.

And to reinforce it, you might even wish to add a note up front, as in:

> For all but the largest size…

> For the 1st, 2nd, 3rd, 4th sizes only…

If it's a single instruction, on one line, that's sufficient. But if there are multiple instructions, make sure it's clear where the rest of the sizes pick back up, as in:

> For the smallest size only:
>
> …
>
> All sizes:
>
> …

Right & Wrong Sides (RS/WS)

When giving individual row instructions, you need to establish which is the right side and which is the wrong side.

You can do this once, as in:

> Row 1 (RS): Knit.
>
> Row 2: Purl.

Or you can do it for every row.

> Row 1 (RS): Knit.
>
> Row 2 (WS): Purl.
>
> Row 3 (RS): K1, p to end of row.
>
> Row 4 (WS): K to last st, p1.

Although this might seem obvious for stockinette stitch, if you're using a pattern stitch, it might not be immediately obvious which side is the "good" one.

And it's absolutely required if, at any point in the pattern, you use an instruction such as

> Work even for 4 inches (10 centimeters), ending with a WS row.

Knitters need to know which is a WS row so they know when to stop. And yes, even if it's stockinette stitch, it's worth stating it.

But this is meaningless:

> CO 100 stitches. Knit 10 rows, ending with a WS row.

Two issues with this: If you've not said which the RS and WS rows are, then I haven't the faintest idea how to end with a WS row. And yes, in this case, it's garter stitch, so the two sides are the same anyway. It's sufficient to say

> Cast on 100 stitches. Knit 10 rows.

When you change to a sided pattern, then establish RS/WS.

Multiple Sizes, Multiple Versions

Presenting the Numbers

There are lots of different ways to divide up the numbers for different sizes. Chose one you like and be consistent.

> Cast on 20 (30, 40, 50) stitches.

> Cast on 20 [30, 40, 50] stitches.

> Cast on 20-30-40-50 stitches.

Some publications use color to distinguish them further, as in:

> Cast on 20 (30, 40, 50) stitches.

However, be aware that if the knitter prints or photocopies your pattern in black and white, color information may be obscured or lost.

If there are more than six or seven sizes, consider indicating an additional subdivision, as in:

Cast on 20 (25, 30, 35, 40, 45, 50, 55, 60, 65, 70, 75) stitches

versus

Cast on 20 (25, 30, 35, 40, 45) [50, 55, 60, 65, 70, 75] stitches.

Multiple Gauges

Some patterns come with more than one set of numbers, but they might not be about sizes. Sometimes, it's about multiple gauges.

For example, a scarf or shawl pattern easily lends itself to being worked with different yarns to produce different versions, and you could list the gauge for each weight of yarn, as in:

CO 100 (80, 60) sts.

But note that in cases like this, it's more common to list the numbers for the finer yarn/smaller size first, so they might seem out of order (i.e., the numbers may decrease instead of increase).

If you're going to do this, make sure it's completely clear which numbers apply to which version, and which yarn and needles to be used for which.

Divide up the size/finished measurements info, and the materials list, as in:

SIZES & MEASUREMENTS

"IF ONLY ONE NUMBER APPEARS"

Many patterns use some kind of standard statement at the start, such as

> Numbers given are for smallest size, with numbers for larger sizes in parentheses. When only one number appears, it applies to all sizes.

For knitters experienced with patterns, this isn't necessary. It's certainly helpful for newer knitters; if your pattern is aimed at absolute beginners, I would make a point of including it—for multisize patterns, of course—but it isn't mandatory.

Scarf—about 10 inches (25.5 centimeters) wide by 55 inches (139.5 centimeters) long.

Stole—about 22 inches (56 centimeters) wide by 70 inches (178 centimeters) long.

MATERIALS

Scarf:

> 2 skeins Nice Yarn Company's Wooly Worsted (200 yd per 100 g skein); sample uses color Winter White.

> U.S. 7/4.5 mm needles.

Stole:

> 3 balls Nice Yarn Company's Charming Chunky (120 yds per 100 g ball); sample uses color Regal Red.

> U.S. 10/6mm needles.

Both versions:

> Stitch markers
> Yarn needle

GAUGE

> Scarf: 20 sts and 28 rows = 4 inches (10 centimeters)square in stockinette stitch using U.S. 7/4.5 mm needles.

> Stole: 14 sts and 20 rows = 4 inches (10 centimeters) square in stockinette stitch using U.S. 10/6 mm needles.

METHOD

> Scarf: Using Wooly Worsted yarn and U.S. 7/4.5 mm needles, CO 55 stitches.

> Stole: Using Charming Chunky yarn and U.S. 10/6 mm needles, CO 39 stitches.

Pop Quiz

How Can This Be Improved?

Row 1 (RS): M1L, kfb, p1 until end.

Row 2 (WS): K2, p2 to end.

It's entirely unclear what is supposed to be repeated in these rows. In Row 1, it could either be

M1L, kfb, p to end

or

[M1l, kfb, p1] to end.

Row 2 is a bit clearer, in that you can probably guess the designer intended (k2, p2) ribbing. But if your instruction requires guessing, then chances are someone will guess wrong.

Row 2 (WS): [K2, p2] to end.

In instructions that follow, numbers for the scarf version appear first and for stole version, second.

Row 1 (RS): (K2, p2) 7 (5) times, k3, (p2, k2) 7 (5) times.

It's straightforward, but make sure complete information is provided for all versions, and label and identify the information very clearly.

Reinforce the difference, if you need to. See:

For scarf, continue until piece measures 50 inches (127 centimeters); for stole, piece should measure 65 inches (165 centimeters).

Repeats

There are three sorts of repeats: repeats within rows, repeats of rows, and repeats of sections.

Repeats within Rows

There are various options for the formatting:

Row 1 (RS): (K2, p2) across.

versus

Row 1 (RS): *K2, p2; rep from * to end of row.

versus

Row 1 (RS): *K2, p2* rep between * and * to end of row.

All are perfectly valid, but I'm less of a fan of the third version. Because the same symbol is used to identify the start and end of the repeated phrase, it can be a little harder to read, especially if there's more than one such repeat in a row.

Do you need to tell the knitter how many times to work a repeat?

If you work the repeat all the way to the end of the row or round, not necessarily. This works just fine:

Round 1: (K2, p2) around.

If you're establishing a pattern, it's helpful to be precise, as in:

Row 1 (RS): Work Lace pattern 5 times across.

And if it's unclear (e.g., if you're only working the pattern partway across the row), then yes. See:

Row 1 (RS): (K2, p2) 10 times, k to end.

Another way to approach this is to provide the instruction relative to the end of the row:

Row 1 (RS): (K2, p2) to last 10 sts, k to end.

Although correct, this one is much less knitter-friendly and less fun to follow:

Row 1 (RS): (K2, p2) 55 times, k to end.

Counting out 55 repeats of that 4-stitch pattern is going to drive the knitter insane.

This sort of thing is helpful, but provides more detail than strictly required:

Row 1 (RS): (K2, p2) 55 times to last 10 sts, k to end.

What if you haven't got an even multiple of the pattern being repeated (e.g., working [k2, p2] ribbing on 18 stitches)? You can't just say to work the pattern repeat across, because that's not correct. Make it clear what to do on those last 2 stitches, as in:

Row 1 (RS): (K2, p2) to last 2 sts, k2.

You sometimes see "end" used in this context:

Row 1 (RS): (K2tog, yo, k1, yo, ssk) across, end k1.

But this can be more confusing. The issue is that this could be read two ways: that after a bunch of full repeats of the lace pattern, you work an

additional k1, or it could mean that you stop midway through the lace pattern, after the k1.

Better to be clearer:

Row 1 (RS): (K1, k2tog, yo, k1, yo, ssk) to last st, k1.

or

Row 1 (RS): (K1, k2tog, yo, k1, yo, ssk) to last 4 sts, k1, k2tog, yo, k1.

Depends on which you intend. Being clearer is more helpful and more reassuring. As a knitter, I'll be more confident that I'm doing it correctly. Also, it's easier to identify if something has gone wrong.

Repeats of Rows

Row 1 (RS): Knit.

Row 2 (WS): Purl.

Easy enough. But then you want to tell knitters to do those a few more times.

Repeat Rows 1 & 2 eight times.

How many rows is that, in total? Ask a room full of knitters, and a fairly lively debate will kick up: is that 16 or 18 rows? Though grammatically this is clear, it's not always as clear in the context of an instruction.

Better to disambiguate:

Repeat Rows 1 & 2 eight more times.

18 rows, easy.

Work Rows 1 & 2 eight times total.

16 rows, nice and clear. Well, fairly clear. The word "total" helps here.

Note that, for ease of reading, I've spelled out the number of repeats (eight) to avoid that number being mistaken for a row number.

If you want knitters to work to a specific length or width, give the measurement and tell them what side to end on:

Work Rows 1 & 2 until piece measures 2 inches (5 centimeters), ending with a WS row.

The phrases "ending with a WS row" and "ending with RS facing" have the same meaning. Anecdotally, many knitters find the first one a little easier to understand. Pick one and be consistent—this kind of thing goes into your style guide.

It's only a repeat of the rows if the rows are actually repeated. That is, if the rows being worked are an exact repeat.

Row 1 (RS): K10, k2tog.

Row 2 (WS): Purl.

Row 3: K9, k2tog.

Row 4: Purl.

Repeat the last 2 rows until 2 sts rem.

This doesn't work. After Row 3, you'll have 10 sts, which makes it impossible to work Row 3 again as it's written.

Better:

Row 1 (RS): K to last 2 sts, k2tog.

Row 2 (WS): Purl.

Repeat the last 2 rows until 2 sts rem.

Pop Quiz

How Can This Be Improved?

Decrease round 1: *K2tog, k2* repeat until end.

Although this is likely to be entirely clear to an experienced pattern reader, this formulation doesn't actually explicitly state what is to be repeated…

Improvement:

> Decrease round 1: *K2tog, k2; repeat from * until end
>
> or
>
> Decrease round 1: [K2tog, k2] to end.

How Can This Be Improved?

> Row 1, establish short rows: 15, w&t, p to end of row.

As soon as you've turned, it's a new row.

Improvement:

> Row 1 (RS): K15, w&t.
>
> Row 2 (WS): P to end of row.

Work pattern round, dec 1 (0, 0) sts evenly around. 22 (26, 28) sts.

Two issues with this (other than the fact that knitters really don't like these types of instructions...):

If there's only one size that needs a decrease, break it out separately. And decreasing 1 st "evenly around" doesn't make a heck of a lot of sense.

Improvement:

First size only: Work in pattern to last 2 sts, k2tog. 22 sts.

Second and third sizes: Work 1 round even in pattern.

This happens a lot in sock heel turns:

> **Row 1 (RS):** K20, ssk, k1, turn.
>
> **Row 2 (WS):** P4, p2tog, p1, turn.
>
> **Row 3 (RS):** K5, ssk, k1, turn.
>
> **Row 4 (WS):** P6, p2tog, k1, turn.
>
> ...

There's a clear pattern here, but you can't just say "repeat these rows," since you're not doing a straight repeat. If you want to save yourself writing out all the rows, go with something such as:

> **Continue in pattern as set, working one more stitch before the decrease each time.**

But consider writing out all the rows if you have space. If there's any possibility that your knitter has never worked this sort of heel turn before, then writing out all the rows is going to be much clearer, and easier for them to work.

Repeats of Sections

Pullover Fronts and Backs are often the same, up to the neckline.

The more traditional (i.e., concise) way to express this would be to put some kind of indicator, often "******" in the instructions for the back, and then the Front would begin:

> **Work as for Back to **.**

More modern patterns are often more descriptive:

> **Work as for back until armhole shaping is complete.**

This takes up more space on the page, but is more helpful, as it contextualizes and better communicates the details of the construction.

Increasing & Decreasing

After increase or decreases, give the resulting stitch count.

> **Cast on 100 stitches.**
>
> **Row 1 (RS):** K1, ssk, k to last 3 sts, k2tog, k1. 98 sts.

If the row is to be repeated, express the change in stitch count on the row, and then the total stitch count after the repeats are complete.

> **Cast on 100 stitches.**
>
> **Row 1 (RS):** K1, ssk, k to last 3 sts, k2tog, k1. 2 sts decreased.
> **Row 2 (WS):** Purl.
>
> **Repeat the last 2 rows 4 more times. 90 stitches.**

As in these examples, it's much more knitter-friendly to be specific about the type of increase and decrease required, and the placement.

An instruction such as "increase at each end of the next row" leaves the choice of the increase method and placement to the knitter. This instruction is more challenging for a newer knitter, and introduces the risk of the finished item not looking like the sample as photographed. That may or may not matter, but understand the impact of the different styles.

If the increase or decrease to be used in a given instruction really and genuinely doesn't matter, then by all means give a generic instruction, but be aware of the implications for the knitter.

The Problem with *Inc* and *Kfb*

Avoid *inc* as an instruction within a row. The problem is that *inc* is a very easy-to-understand abbreviation of the word "increase," and, as such, is the sort of thing that a knitter may well not bother

DON'T DO THIS

The single most egregious example I have ever seen looked like this:

> Next row (RS): Knit, working 38 (41, 45, 43, 42, 37, 41) YOs spaced evenly across the 198 (211, 218, 241, 266, 290, 312) stitches of the body.

It's from a pretty popular pattern. I'm entirely sympathetic to the designer and can understand why she chose to use this construction. After all, there are seven sizes and therefore seven different instructions to work out. This one is actually so disliked that knitters have written an online tool to calculate the specific row instructions for you. Long blog posts and Ravelry rants have been written.

This construction is not wrong, but in a pattern that is otherwise pretty beginner-friendly, it feels out of place. Writing it out does require seven different instructions, and it can take up a fair bit of space. Consider writing out the detailed instructions, but putting them outside the flow of the main instructions, in a sidebar or a pattern note, that knitters can consult for help if they want it. Just make sure knitters know it's there. At the end of this row instruction, add something like "See Pattern Notes for more detail."

to look up in the glossary. The knitter may well just forge ahead with her own preference of increase.

The issue is that there are two categories of increases: the "make" family and the "fb" family. The "make one" stitches—M1R, M1L, LLI, RLI, etc.—make a stitch from nothing, creating a stitch between existing stitches. The "fb" family—kfb, pfb—takes a single stitch and makes it into two.

If you've got 10 stitches, for example, inc can get you into trouble with an instruction as in:

Row 1 (RS): K5, inc, k5.

Using either kfb or pfb here would leave you without enough stitches to finish knitting the row.

Sometimes it's phrased as "inc in the next stitch," which is somewhat clearer in that it hints that you're using a stitch for the increase, but again, you're making the knitter guess. If a knitter doesn't know the kfb, things can go wrong. Use a precise instruction; it's simpler for everyone.

"Evenly Distributed Across..."

> Increase 5 stitches evenly distributed across the next row.

> Knit, decreasing 10 stitches evenly across the round.

Concise, sure. But very few knitters enjoy these sorts of instructions.

Unless your pattern is aimed at very experienced knitters, and the increase/decrease method really doesn't matter, take the time and space required to write out the instruction in detail.

> Next row (RS): K10, (M1, k9) 5 times. 60 stitches.

> Next row (RS): (K8, k2tog) 10 times. 90 stitches.

It takes you a bit more time, but it means that your knitters can keep knitting, rather than having to stop to dig out a calculator.

"Work Even"

After a set of increases or decreases is completed, "work even" is a nice convention that's used to instruct the knitter to continue in pattern, without further increasing or decreasing, on the stitch count they now have, as in:

Don't Just Take It From Me

> My biggest beef is "Increase 15 stitches evenly over the next row." Would it be too hard to provide the more detailed instruction?

> I hate it when I have to "decrease evenly" or "reverse shaping." I like it when all that is spelled out for me.

Pop Quiz

How Can This Be Improved?

Row 1 (RS): (K1, p1) 4 times to first marker, slip marker, (k1, p1) 8 times to second marker, slip marker, (k1, p1) 4 times to end of row.

If you look closely at this, you can see that what's actually happening is very simple: (k1, p1) to the end of the row. This instruction is providing so much extra info that it's become difficult to read and understand.

Row 1 (RS): K1, ssk, k to last 3 sts, k2tog, k1. 2 sts decreased.

Row 2 (WS): Purl.

Repeat the last 2 rows 4 more times. 90 stitches.

Work even until piece measures 10 inches (25 centimeters), ending with a WS row.

On Distances

You'll often need to tell the knitter to work even for a certain length or until the piece reaches a particular size (See Work Even.)

Don't forget to let the knitter know if they need to finish on a particular row/round, as in:

Work even for 4 inches, ending with a WS row.

Work even until scarf measures desired length, ending with Row 10 of the Lace Pattern.

By Rows or Rounds

In a pattern that's written out row by row/round by round, it's not uncommon to see a set of rows/rounds worked even, as in:

Rows 10–13: Work even in garter stitch.

Rounds 78–83: Work even in stockinette stitch.

Rows 57–104: Work even in stockinette stitch.

When it's a small number of rows (e.g., no more than about four or five), as in the first examples above, this is a great way to do it, because in this presentation there's an assumption that the knitter is reading and keeping track of their progress by counting off those rows/rounds.

But over more than a few rows/rounds, as in the final examples, it can become a counting problem. On a very simple level, it's easier to count off rows starting at one than it is starting at 57 or 78. If the math is not immediately obvious for the number of rows in a section, as in the second and third examples, then you risk making an error or misreading. And if it's a lot of rows/rounds, as in the third example, then it's even more likely the knitter will lose track.

Be explicit about the number of rows/rounds to be worked. For the second example, either

Work 6 rounds in stockinette stitch

or

Knit 6 rounds

is quicker and easier to understand.

It's clearer and easier to follow if you add the number of rows/rounds to be worked, as in:

...

Row 8 (WS): Knit.

Row 9 (RS): K1, ssk, k to last 3 sts, k2tog, k1. 36 sts.

Rows 10–13: Work 4 rows even in garter stitch.

Row 14 (WS): K1, M1, k to last st, M1, k1. 38 sts.

...

Rounds 78–83: Work even in stockinette stitch for 6 rounds.

Rows 57–104: Work even in stockinette stitch for 48 rows.

For longer sections, if your pattern permits, consider changing the instructions to do it by measurement.

Work even for 7.25 inches (18.5 centimeters), ending with a WS row.

"Until Desired Length"

Be careful with "work until piece is desired length"—without context, this can cause trouble.

A designer I know likes to use "work sock foot to desired length before toe" in her top-down sock patterns, which is not very helpful unless you tell

the knitter how much space you need to leave for the toe. For example:

> Work sock foot until it measures 2 inches (5 centimeters) short of full foot length.

I saw a mitten pattern once that said "knit until thumb measures 2.5 inches (6.5 centimeters), or to desired length," but again, without further information I didn't know what the desired length might be. (In this case, the final shaping took only 2 rounds, so you needed to knit until the mitten thumb was the full length of the wearer's thumb.)

If there's a significant distance to be worked after this point, provide guidance, such as:

> Work until blanket is desired length, noting that upper border adds 3 inches (7.5 centimeters) to the finished size.

For a scarf or other type of item, consider how this instruction might affect or be affected by yardage:

> Work until piece is desired length, ensuring that you leave at least four yards of yarn left for the bind-off.

> Work until piece is desired length. If you wish to make it longer than 60 inches (152.5 centimeters), you may need an additional skein of yarn.

Stitch Markers

Stitch markers are required for a piece worked on a circular needle in the round:

> Place marker and join for working in the round.

Without this marker, the start of the round isn't easy to find.

(For a smaller circumference piece worked in the round, see page 60.)

Markers are also useful for dividing pattern sections up, as in:

> Knit to marker, work lace motif to next marker, k to end.

Instructions to slip the marker are only needed when it's ambiguous. For example:

> K to marker, M1, k to end.

The knitter could end up with the increase on either side of the marker, so you need to be clear:

> K to marker, M1, slip marker, k to end.

> *or*

> K to marker, slip marker, M1, k to end.

Marker use can simplify instructions, too. Compare:

> **Round 1:** (K9, k2tog) 10 (11, 12) times around. 100 (110, 120) sts.

> **Rounds 2, 4, 6, 8:** Knit.

> **Round 3:** (K8, k2tog) 10 (11, 12) times around. 90 (99, 108) sts.

> **Round 5:** (K7, k2tog) 10 (11, 12) times around. 80 (88, 96) sts.

> **Round 7:** (K6, k2tog) 10 (11, 12) times around. 70 (77, 84) sts.

> **Round 9:** (K5, k2tog) 10 (11, 12) times around. 60 (66, 72) sts.

> **Round 11:** (K4, k2tog) 10 (11, 12) times around. 50 (55, 60) sts.

> **Round 13:** (K3, k2tog) 10 (11, 12) times around. 40 (44, 48) sts.

> **Round 15:** (K2, k2tog) 10 (11, 12) times around. 30 (33, 36) sts.

> **Round 17:** (K1, k2tog) 10 (11, 12) times around. 20 (22, 24) sts.

> **Round 19:** K2tog around. 10 (11, 12) sts.

with:

> **Decrease round:** (K9, k2tog, place marker) 10 (11, 12) times around. 100 (110, 120) sts.

Pop Quiz

How Can This Be Improved?

Seed St

Round 1: (K1, p1) around.

Round 2: (P1, k1) around.

METHOD

Cast on 65 sts, join for working in the round. Work Seed St for 3 inches (7.5 centimeters).

If you're asking for Seed Stitch to be worked on an odd number of stitches, make sure you define it for an odd number of stitches (the glossary instruction above is worked over an even number).

Following round: Knit.

Round 3: (K to 2 sts before marker, k2tog) 10 (11, 12) times around. 10 (11, 12) sts decreased. Repeat the last 2 rounds 8 more times, until 10 (11, 12) sts rem.

This second version actually increases the knitter's chance of success, as they need only rely on markers, rather than counting stitches. And there's no need to count rounds, other than to keep track of decrease and even rounds.

Pattern Stitches

Placement

Some designers create a special Pattern Stitches section, often in or near the glossary and techniques section, to group together all charts and pattern stitches.

Others place these items in the pattern flow, positioned where the knitter is likely to need them.

Either approach is fine—it's a question of preference. Just make sure that whichever way you choose, they're easy to find.

When & How to Define Stitches

If your instructions require or refer to a pattern stitch, such as:

> Work 12 rows Double Moss Stitch

or

> Rnd 1: Work Lace Panel, k to end

then it's pretty clear that you need to define it, as in:

TYPOS I HAVE KNOWN

Ruth Garcia-Alcantud tells a story about a Norwegian colorwork pattern that implored the knitter to "cut the steak."

Double Moss Stitch (worked flat over an even number of stitches):

Rows 1 & 2: (K1, p1) across.

Rows 3 & 4: (P1, k1) across.

Note that there's no RS/WS indicators here because the fabric is reversible, but also because you're collapsing two consecutive rows into one instruction, a right-side and a wrong-side row.

Lace Panel (worked in the round over 7 stitches):

Round 1: K2, k2tog, yo, k3.

TO COUNT OR NOT TO COUNT

Compare the two versions of the following WS rows:

Rows 2, 4, 6, 8 (WS): K1, p58, k1.

versus

Rows 2, 4, 6, 8 (WS): K1, p to last st, k1.

Both are absolutely correct, but the second one is more knitter-friendly because the only thing you need to count is the last stitch. In the first version, the knitter may think they must count off those 58 stitches, and that's both boring and error-prone.

KNIT THE KNITS & PURL THE PURLS

It's not uncommon, particularly in the context of a rib or cable pattern, to have the instructions for the 'odd'/unpatterned rows given as simply "knit the knits and purl the purls," or "work the stitches as they appear."

This convention was used a lot when printing and shipping costs were a major concern. It's a valid way to express a pattern instruction, but requires a fair bit of knowledge on the part of the knitter. As a designer, ask yourself if you are confident that your knitter will be able to identify the knits and purls without an issue. Even for a basic ribbing pattern, this is not always obvious to a beginner knitter. And for a more complex cable pattern, this can stump even a seasoned knitter, since stitches that have been crossed on the previous row/round can be hard to read.

Round 2 and all following even rounds: Knit.

Round 3: K1, k2tog, yo, k1, yo, ssk, k1.

Round 5: K2tog, yo, k3, yo, ssk.

Round 7: K2tog, yo, k2, k2tog, yo, k1.

Round 9: K2, yo, k3tog, yo, k2.

Round 10: Knit.

If the pattern is worked flat, provide instructions for working it flat; if it's worked in the round, provide instructions for working it in the round. And if it's worked both ways, provide both.

Pay attention to stitch counts—see the sidebar on the next page. Indicate the number of stitches in the pattern or the repeat.

Note that for the lace panel example above, the even rounds are worked plain. There's no need to write them all out individually, but you do need to indicate the final row or round of the repeat, so that it's clear where the pattern ends. You can do this a couple of ways. Above, I've given the generic "all following even rounds," (or "all foll," too, of course) but make sure to include Round 10 on its own, as I did above, so that it's clear it's the last one in the repeat. You could also use the following format:

Rounds 2, 4, 6, 8, 10: Knit.

Either way, you need to be clear about which is the final round, so the knitter knows where the pattern ends. Without that, an instruction such as "work until the pattern is complete" is ambiguous.

It can help readability of the pattern if a repeated element is pulled out and documented separately, especially if it's used a lot.

For example, although the following is entirely correct:

BACK

Row 1 (RS): K21, k2tog, yo, k1, yo, ssk, k1, k2tog, yo, k21.

Row 2 (WS): Purl.

Row 3: K20, k2tog, yo, k3, yo, s2kpo, yo, k22.

Row 4: Purl

Row 5: K21, yo, s2kpo, yo k1, k2tog, yo, k23.

Row 6: Purl.

Row 7: K22, yo, s2kpo, yo, k1, yo, ssk, k22.

Row 8: Purl.

It's much easier to see the bigger picture with an instruction as in:

BACK

Row 1 (RS): K20, work lace patt across next 10 sts, k to end.

Row 2 (WS): P20, work lace patt across next 10 sts, p to end.

Work as set until 20 rows of lace pattern are complete.

Assuming, of course, you've defined the lace pattern somewhere.

Additionally, this kind of construction is more concise and easier for your tech editor to check. If you take the first approach, then you'll need to incorporate the specific instructions for the pattern into the row-by-row instructions for the Back, the Front(s) and any other sections that use that pattern.

Pulling a specific pattern stitch out makes swatching much easier, too.

I recently encountered a pattern that folded the specific stitch instructions into the main instructions, as in the example above. The gauge

Pop Quiz

How Can This Be Improved?

CO 80 stitches.

Next row (WS): P2, *k4, p2; repeat from * across.

Continue working k2, p4 rib for 1 inch (2.5 centimeters).

These instructions don't actually fully define the pattern… the RS row is not worked the same way as the WS, and without explicit direction, many knitters will become lost—or at the very least, feel uncertain.

In addition, a more subtle point is that the designer is using the name "k2, p4" rib without actually making it clear that he means the pattern stitch as set in the row above. (And because the row as spelled out features neither k2 nor p4, it can't be taken for granted that this is clear.)

And of course, we don't know whether the knitter is to stop with a WS or RS row…

Better:

CO 80 stitches.

Row 1 (WS): K2, *k4, p2; repeat from * across.

Row 2 (RS): K2, *p4, k2; repeat from * across.

These two rows set (k2, p4) ribbing pattern. Continue in ribbing as set for 1 inch (2.5 centimeters), ending with a WS row.

ON RIBBING

Do you need to define ribbing patterns? If writing for more experienced knitters, it's sufficient to simply indicate the pattern that needs to be worked, for example:

Work 2 inches (5 centimeters) of (k2, p2) ribbing.

But for newer knitters, the instructions should be spelled out, especially if there's something irregular about them.

For example, (k1, p1) ribbing worked over an even number of stitches is simple: both rows are the same. But worked over an odd number of stitches, the two rows differ. Your decision about how to present the instruction relies on your assumption about the experience level of the knitter. If you think you **might** need to define it, then you **do.**

was given in pattern stitch, 24 stitches over four inches (10 centimeters). To check her gauge, the knitter cast on 24 stitches. She wasn't able to make the pattern work in her swatch, though, because the repeat required a larger number of stitches—actually 28. Without any additional guidance, all she was able to do was try to work the main pattern rows, the instructions for the back of her sweater, over the 24 stitches she had cast on. Because she didn't have enough stitches, she failed miserably. Her question to me was whether she needed to work the full back width to check her gauge. This sort of pattern writing encourages knitters to skip the swatch: If they can't figure out how to do it, they won't.

Charts

...and Written Instructions

Where possible, include both charts and written instructions for pattern stitches. Knitters often have a strong preference for one or the other, and it's not about skill level or experience, it's about learning style. Knitters who are visual learners or are good at pattern recognition often prefer charts; knitters who are auditory learners often prefer written instructions.

It's more inclusive to provide both. Blind or partially sighted knitters—of which there are

more than you might think—need written instructions for their screen-reading software.

It's not always practical to provide both, of course; a 48-row, 36-stitch cable pattern is going to be pretty unwieldy in written format, and the more complex the written instructions, the higher the risk of error. But if the pattern is less than about 24 stitches and rows/rounds, I highly recommend you include both charts and written instructions.

And let knitters know they have a choice:

Working from written or charted instructions, proceed:

Round 1 (RS): Work Cable Pattern across first 24 sts, k to end of round.

If you're including a chart in addition to written instructions, be clear about it, and about how to use it.

For example, I recently edited a pattern that included these instructions:

Cast on 60 sts, work from chart or written instructions.

Row 1 (RS): K45, k3tog, yo, k1, yo, k1.

Rows 2, 4, 6, 8 (WS): K1, p58, k1.

Row 3: K43, k3tog, k1, yo, k1, yo, k2.

Row 5: K41, k3tog, k2, yo, k1, yo, k3.

Row 7: K39, k3tog, k3, yo, k1, yo, k4.

Work the pattern as set until the piece measures 10 inches (25.5 centimeters), ending with a full pattern repeat.

And a chart that looked like this:

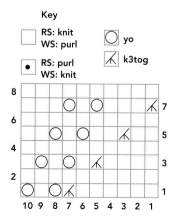

On Charts & Written Instructions

A Case Study

A knitter recently came to me, very confused about a pattern. It's a rather fascinating example of a "correct but not" pattern and worth examining in detail.

After the cast-on and set-up rows, the instructions said:

Work Chart 1 to end of chart as follows:

> Row 1 (RS): K2, yo, k1, *ssk, k2, yo, k1, yo, k2, k2tog, k1*; rep from * to * once more, yo, k1, yo, k1, rep from * to * twice more, yo, k2.
>
> Row 2 (WS): …

All the way up to Row 20.

And with a chart as in the one below.

What's presented is entirely correct, but my not-very-confident pattern reader had a lot of problems with it.

First of all, there's a number of ways in which the written row instructions can be simplified and clarified. The use of * for noting the start and end of the repeat is easy to misread, and the phrasing "rep from * to * once more" is unwieldy.

Rather than:

> *ssk, k2, yo, k1, yo, k2, k2tog, k1*; rep from * to * once more

It's tidier and easier to read as:

> [ssk, k2, yo, k1, yo, k2, k2tog, k1] twice.

At first blush, the symmetry isn't obvious: there are actually two repeats of the pattern phrase on either side of the central stitch, but as the pattern is written out, on the first half you repeat once, and on the second side you repeat twice. Although this is correct and it works, it's not clear. Consider:

> Row 1 (RS): K2, yo, k1, [ssk, k2, yo, k1, yo, k2, k2tog, k1] twice, yo, k1, yo, k1, [ssk, k2, yo, k1, yo, k2, k2tog, k1] twice, yo, k2.

This makes it easier to read, and the basic construction clearer—that there's a starting edge, a central "spine" element, and an ending edge, and between them are two repeats of a pattern stitch.

What this loses, though, is an easy way to see that the pattern stitch is the same on each side of the central element.

An easy alternative would be define the pattern stitch separately, as in:

> Lace Pattern (worked flat over 10 stitches):
>
> Row 1 (RS): SSK, k2, yo, k1, yo, k2, k2tog, k1.
>
> …

And then your main instruction would be as follows:

> Row 1 (RS): K2, yo, k1, work Lace pattern twice, yo, k1, yo, k1, work Lace pattern twice, yo, k2.
>
> …

This would also make the chart more concise. As given, the chart covered the full piece, including the edges.

The revised version would permit a simple 10-stitch chart (see chart, next page).

But then the pattern got more complicated.

Key

☐ RS: knit / WS: purl	⭕ yo	⟋ k2tog
⊡ RS: purl / WS: knit	⋀ CCD	⟍ SSK
		☐ 10-stitch repeat
		▨ no stitch

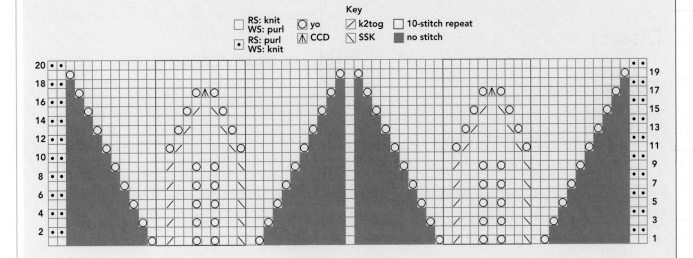

After the initial 20 rows, the instructions said:

> Repeat Rows 1 to 20 of chart, 4 more times, noting that reps between * to * will increase 2 reps on each side of center stitch every 20 rows.

My student was stopped by this entirely, and I have to confess it took me a minute or two to work out.

My knitter hadn't been working from the chart, and didn't feel confident about reading it, so upon being told that she had to work the chart, she was ready to give up.

The language the pattern used here was confusing. If it had simply said

> Repeat Rows 1 to 20 of pattern, 4 more times

then she would have been more confident about proceeding.

Looking back to the first instruction, it gave:

> Work Chart 1 to end of chart as follows:

Leaving aside that is sort of strangely nonsensical and redundant, a non-chart reader ignores that line (heck, many knitters probably would), and just works Rows 1–20 from the written instructions. Changing that initial instruction to read:

> Work Rows 1–20, working from chart or written instructions as you prefer,

makes the bigger picture clear: the written instructions and the chart are the same, and you can work from either.

And then when it's time for the repeat, you can say:

> Continue, working Rows 1–20 four more times.

On the issue of the repeats of the motif, then we have this to figure out, too:

> … noting that reps between * to * will increase 2 reps on each side of center stitch every 20 rows.

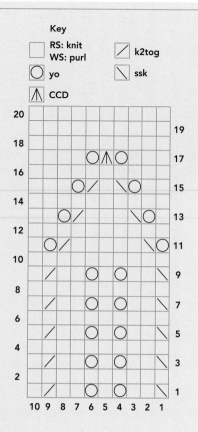

Key

☐ RS: knit / WS: purl	⟋ k2tog
◯ yo	⟍ ssk
⋀ CCD	

Consider:

> Working additional repeats of the 10-stitch motif as required.

If you want provide some extra detail, then something as in the following can be very helpful:

> Every repeat of the 20-row pattern will add four more repeats—one at the start of the row, one before the central spine, one after the central spine, one before the end of the row.

Notice that the chart doesn't match the written instructions—it leaves off the large expanse of stockinette stitch. That's fine, and it's a sensible use of space. The issue is that it's not clear from reading the instructions how to use the chart, how it fits into the rows.

Really, it needs to go like this:

> **Row 1 (RS):** K39, work lace pattern over next 10 sts, k1.
>
> **Rows 2, 4, 6, 8 (WS):** K1, p to last st, k1.
>
> **Continue as set until piece measures 10 inches (25.5 centimeters), ending after a full pattern repeat.**

Be sure to provide the chart and written instructions for the 10-stitch repeat nearby.

Reversing Shapings

I did an informal survey of knitters, asking them about things in patterns that make them crazy. Being instructed to reverse shaping was number one.

This used to be a standard approach for working garment fronts: The instructions for the right side of the neckline would be written out in detail, and the left side would simply be given as "work as for Right, reversing all shapings."

I like charts **and** written instructions. I use the charts, but text instructions provide a good check for errors and are helpful for beginners (and blind knitters!).

I like charts, but please always provide written instructions, too.

I love patterns that have both diagrams (charts) **and** written directions.

I can excuse older patterns because they needed to be concise, but unless you're writing for very experienced knitters, this style of instruction just isn't knitter-friendly.

I highly recommend writing out all the rows.

It's also worth adding a little bit of editorial guidance to help keep knitters on track, and help them see the big picture:

> **The Right Front is worked the same as the Left Front, with shapings reversed, as follows...**

I have seen a couple of books take this one step further by providing both instructions—the "big picture" concise ones, and the step-by-step ones—in an appendix or separate pattern note. For example:

> **Right Front: Work as for Left Front, reversing shapings. For row-by-row instructions, see Appendix.**

"At The Same Time"

Knitters aren't keen on this kind of instruction, either, but it sometimes can't be avoided. It comes up relatively often in shaping the fronts of a V-neck garment: the armholes and the neckline shaping are often worked simultaneously.

It's all about when the two different elements start. If they start at the same time, adding a bit more detail can allow you to be precise and explicit about it.

The instruction

> **Decrease at beg of every RS row 5 times WHILE AT THE SAME TIME decrease at end of every RS row 20 times. 11 sts**

can also be written as

> **Row 1 (RS): K2, ssk, k28, k2tog, k2, turn. Slip rem sts to a holder for Right Front. Left Front will be worked on these 34 sts.**

> **Row 2 (WS): Purl.**

> **Row 3: K2, ssk, k to last 4 sts, k2tog, k1. 2 sts decreased.**

> **Repeat the last 2 rows 3 more times. 26 sts.**

> **Next row (WS): Purl.**

> **Next row (RS): K to last 4 sts, k2tog, k1.**

> **Repeat the last 2 rows 15 more times. 11 stitches.**

Pop Quiz

How Can This Be Improved?

Continue as set, working rounds 1–8 of the chart a total of six times. On the last round before heel flap, end 3 (5) stitches before end of round.

A knitter who follows the instructions line by line may well not bother reading that last sentence until after the six full repeats are complete.

Better:

> Continue as set, working rounds 1–8 of the chart a total of five times, and work rounds 1–7 again.

> Final round: Work as set until 3 (5) sts rem; end here.

BECOMING A BETTER PATTERN WRITER: Teach Some Classes

I've taught over fifty different classes, some of them hundreds of times, since 2003. My favorite of all, and the one I teach the most, is the Project Class. It's a guided workshop over four or five weeks. Knitters bring in whatever they're working on, and I help them with it. This keeps me very much in touch with what knitters find challenging to do and what they find challenging to understand.

For example, being of a mathematical bent, I've never personally struggled with instructions such as "decrease 5 stitches evenly across the rows," so when I started writing patterns it never occurred to me that it might be difficult for others. But I find myself explaining how to deal with this at least once a week. Needless to say, I have become very conscious of this type of instruction, and now I avoid using it.

If the elements don't start at the same point, and indeed they start at different points for different sizes, then there is no choice but to resort to the "AT THE SAME TIME" type of instruction.

But there are two things you can do to make it easier for knitters: warn them up front that it's going to happen and then make it very clear in the instructions.

> **Right Front Neck and Armhole Shaping:**
>
> **Note: For this section, you will be working shaping at both the neckline and armhole edges simultaneously. Read ahead before you proceed.**
>
> **Next Row, decrease for neckline (RS): K to last 3 sts, k2tog, k1.**
>
> **Work 3 rows in patt as set.**
>
> **Repeat these 4 rows 15 (15, 17) times more, and AT THE SAME TIME, when work measures 9.5 (10, 10.5)" [24 (25.5, 26.5) cm], ending with a WS row, shape armhole as follows:**
>
> **Continuing neckline shaping as set, work the following shaping at the beginning of RS rows ONLY.**

Working in the Round

We've already discussed some key considerations when writing a pattern for working in the round:

- Always identify rounds as rounds.

- Be clear about the needles required—if a long circular, be clear about the length (See Materials & Equipment, page 15.)

- Define any pattern stitches properly.

Don't Just Take It From Me

I don't like patterns written for a specific sort of needle. Socks seem to be the primary victim here. Don't write them for sets of four or five needles, and use stitch amounts, not needle numbers.

On Needle Specificity: Small Circumferences in the Round

Small circumference items (e.g., socks, mittens, sleeve cuffs, hat tops) require special needles. Traditionally, this would have been DPNs, but knitters are now using a variety of methods with other tools, including magic loop, two circulars, or even tiny little 8- or 9-inch (20- or 23-centimeter) circulars.

There are two ways to approach listing needles required for small-circumference items: you can be precise and detailed about the needles to be used, or you can be nonspecific. It's entirely a style choice. Note that you can be more detailed with needle-specific instructions, breaking down how stitches are to be arranged, which can be helpful to less-experienced knitters, as in:

> Cast on 56 stitches. Put 20 stitches each on two DPNs and 16 on a third. Join for working in the round.
>
> *or*
>
> Decrease round: (K to the last 2 sts of the needle, k2tog) four times.

Or you can be more inclusive with needle-agnostic instructions, enabling knitters to use whichever needles they want:

> Cast on 56 stitches. Distribute sts across needles as you prefer and join for working in the round.
>
> Setup for decrease: Divide the stitches into four equal groups. Redistribute sts or place markers as required.
>
> Decrease round: (K to the last 2 sts of the quarter, k2tog) four times.

Knitters often have a strong preference for which needles to use for small circumference. Some knitters will never give up their DPNs, others have shunned DPNs entirely, in favor of the magic-loop method. Some knitters may only know how to use one configuration.

Writing a pattern with specific references to a needle configuration risks excluding knitters who don't know how to work that way, or simply don't enjoy it. A more-experienced knitter may well be able to convert a pattern to their own specific requirements—for example, the instructions for decreasing the crown of a hat are usually easily understood and converted—but whether the knitter has the skills or not, they often simply don't want to have to make the effort. Many knitters have told me that they simply won't buy a pattern that is written for needles they don't use.

I write my sock patterns in a needle-agnostic manner, and I use that as a selling feature. This type of setup does require a little bit more knowledge and experience on the part of the knitter, so I don't do it for patterns aimed at absolute beginners, but I find it otherwise broadens my audience.

I do still provide information about and guidance on stitch arrangement, using the geography of the sock to guide the knitter. For example:

> **If you're working on DPNs, the instep stitches will be grouped together on one needle, the stitches of the sole divided across two. If you're working with Magic Loop or two circulars, the instep stitches will be grouped together on one needle, the stitches of the sole on the other. Place a marker in the center of the sole needle for the start of the round.**
>
> **K to the last 3 sts before the instep, k2tog, k1; work across instep in pattern as set; k1, ssk, k to end of round.**

When doing this, I'll also use punctuation to help; I use semicolons to separate instructions for different groups of stitches.

You can use markers in this situation, too, with a note acknowledging needle configurations.

A sock designer I know uses this type of instruction.

> **With RS facing, pick up and knit 16 stitches along the first side of the heel flap; at this point either place a marker or start a new needle for the instep. The instructions below refer to**

markers; in some cases, the start of the needle might act as a virtual marker.

For the crown decrease of a hat, it might go like this:

> **Round 1, set up markers for decrease: (K10, k2tog, place marker) 8 times around.**
>
> **Round 2: Knit.**
>
> **Round 3: (K to 2 sts before marker, k2tog) around.**
>
> **Repeat the last 2 rounds until 16 sts rem. When the circumference gets too small to work comfortably on the circular needle, change to DPNs/Magic Loop/Two Circulars as you prefer.**

Written like this, you're assuming that the knitter either arranges the stitches so that the markers stay in the middle of the needle, or has enough experience to know that the end of a needle effectively functions as a marker. For a newer knitter, a statement such as this can be useful:

> **Arrange your stitches so that you've got full repeats on each needle. The marker at the end of the last repeat on a needle will fall off; you can choose to place a safety pin or removable stitch marker in the fabric of the hat at that point, or just remember that the end of the needle acts as a marker.**

Ultimately, all these methods—four or five DPNs, magic loop, two circulars, tiny circulars—produce the same result, and the needles used shouldn't

matter. I feel very strongly that unless there's a good reason for it, the patterns should permit the knitter's choice of needles.

WHAT'S A "GOOD REASON"?

If the pattern is aimed at newer knitters or is a teaching tool, then it's entirely appropriate to write detailed, needle-specific instructions. It's also appropriate if there's a construction reason—for example, a sock worked on the bias or lengthways, that has a much larger than usual stitch count.

Marking the Start of the Round

When working on a circular needle in the conventional manner, a marker is always required for the start of the round. The issue is that it's not immediately clear where the start of the round is.

For a small circumference on a DPN-, magic-loop or two circulars setup, there's some debate over whether a marker is even required because the start of the round has a limited number of possible positions: at the breaks between two needles. For magic loop or two circulars, there are only two possible positions; for DPNs, there are three or four, depending on many needles are being used. The location of the cast-on tail provides the answer.

A marker at the start of a needle in a DPNs or two-circulars setup won't stay on, and a marker on the loop of a magic loop will move around and get in the way.

Don't Just Take It From Me

I really like a clear description of which pieces fit together where. Not just a schematic, but which edge is which. I recently frogged a stuffed animal (which was not, itself, a frog) after my third failed attempt at putting the head together.

For this reason, the following instruction is not nearly as helpful as it seems:

> Cast 56 sts. Distribute across DPNs. Place marker and join for working in the round.

Experienced knitters will interpret this figuratively, using their own method for keeping track of the start of the round—some will place a safety pin or removable stitch marker in the cast-on edge at the start of the round; some will place a marker after the second stitch; some will just keep track of the tail. But newer knitters will take the instruction literally and struggle to keep a marker on at the start of a DPN.

In a situation like this, it's up for debate whether a marker is even required. If you do want to specify marker use, consider a more generic phrasing, as in, "Note or mark start of round," or a more precise instruction to place a pin in the cast-on edge.

"Being Careful Not to Twist"

This is another potentially optional instruction, and there's debate on whether it is required. It's a question of your style sheet and the level of your knitter.

It's certainly required for knitters new to working in the round to be told not to twist the stitches, and experienced knitters value the reminder to check that their stitches are not twisted before they proceed.

Of course, if you're working a Möebius, then do be explicit that there needs to be a twist in the round.

Finishing Instructions

These are easily forgotten, but be sure not to forget them. Even if the piece has no seaming, surely there are ends to be woven in. And are there specific blocking instructions?

If there are seams or there's assembly to be done, provide clear instructions. "Assemble" or "seam" is not sufficient. Because finishing is both a source of confusion and fear for many knitters, and at the same time such an important step in the process, it's worth being detailed and precise.

If there are seams, give the order of assembly, as in:

Sew shoulder seams. Set in sleeves. Sew body and sleeve seam.

Again, consider your knitter. Is this likely to be a first garment? Consider being clear about blocking—when and how to do it, for example:

MATTRESS, KITCHENER & PICK UP

There is debate about whether the term "mattress stitch" is generic, referring to all seams of knit garments, or whether it only applies to the technique used to seam the sides of knit pieces together. Because of this, it can be confusing to knitters. I tend to avoid it unless I'm also providing detailed information about how I expect it to be worked (and references) in a pattern for less-experienced knitters, for example. Kitchener stitch is named after a person, Lord Kitchener, and therefore requires capitalization. Of course, "graft" is a perfectly good term, too.

"Pick up" and "pick up and knit" are used in various ways: sometimes to mean the same thing, sometimes to mean different things. (It's like 'flammable' and 'inflammable'.)

Broad generalization alert: In general, both "pick up" and "pick up and knit" are typically interpreted as the maneuver where you insert the tip of the needle under the edge of the knit piece, wrap the yarn around the needle tip as if to knit, and bring that loop of yarn through the edge. If you mean the "other" pick-up—just grabbing a strand of yarn at the edge of the piece and putting it on the needle to form a loop, threading the needle through the edge, without working it, be clear.

Wash pieces before seaming. If you're using a machine-washable yarn, a gentle machine wash is fine, but lay the pieces flat to air-dry.

Bits & Pieces

The Cast-On & Bind-Off

These aren't rows—don't count or label them with numbers.

A row that has some stitches cast on or bound off within it, though, has a number, of course, as in:

Row 21 (RS): BO 6, k to end.

But you shouldn't put a row number on an instruction such as,

BO all sts.

And if there's a BO worked in the middle of a row, or after a set of stitches, it can cause problems and confusion in the counting:

Next row (RS): K20, BO 5, k10, BO 5, k to end of row.

Here's the issue: You need 2 stitches on your right needle to BO, and since you've already got several, different knitters might interpret this different ways. Do you start your BO immediately after the 20 knit stitches, knitting the 21st stitch, and lift the 20th over it? Or do you knit the 21st and 22nd, and lift the 21st over the 22nd? This instruction (most likely) is intended to result in the knitter lifting the 21st stitch over the 22nd, so 20 stitches remain on the right needle before the break created by the bind-off. But you can't guarantee that a knitter will read it that way.

Consider adding a few words to explain your intentions—even experienced knitters find this confusing.

And the middle bit can be tricky, too. When the BO 5 is done, there's a single stitch left on your right needle. Is that part of the 10 that are to be knitted, or no? Consider changing the phrasing, or just giving some guidance in parentheses, such as:

BO 5, k10 (11 sts on right needle after BO).

The Treasure Hunt

A couple of years ago a knitter posted a lengthy set of comments on Ravelry about things she does and doesn't like in patterns. One phrase in particular struck me: Don't make the instructions a treasure hunt. It's a great way of phrasing a particular problem that can pop up in written pattern instructions.

When you've got a multi-row pattern that has many repeated rows, it makes sense to condense the written instructions by indicating rows that are the same.

For example, if we look at the chart on the right, we can see that all WS rows are the same, and Rows 1, 3, 5, 7, 9 are the same.

In written instructions, therefore, you can save yourself a fair bit of space by showing which rows repeat, as in:

> Rows 1, 3, 5, 7, 9 (RS): SSK, k2, yo, k1, yo, k2, k2tog, k1.
>
> Row 2 and all following even rows (WS): Purl.
>
> Row 11: Yo, ssk, k5, k2tog, yo, k1.
>
> Row 13: K1, yo, ssk, k3, k2tog, yo, k2.
>
> Row 15: K2, yo, ssk, k1, k2tog, yo, k3.
>
> Row 17: K3, yo, CDD, yo, k4.
>
> Row 19: Knit.
>
> Row 20: Purl

Simple.

But it gets more challenging for both the pattern writer and pattern reader when the rows that repeat aren't consecutive, or there are multiple repeats within the same set of rows, as in:

> Row 1 (RS): Knit.
>
> Row 2 (WS): Sl 1 purlwise wyif, p to last st, k1.
>
> Row 3: Bind off 12 sts, [yo twice, k2tog] 12 times, k2.
>
> Row 4: Sl 1 purlwise wyif, p1, [p2, k1] 12 times, k1.
>
> Row 5: K1, [k1, p1, k1 tbl, k1, k1 tbl, p1] 9 times, k2.
>
> Row 6: Sl 1 purlwise wyif, p1, [k1, k1 tbl, p1, k1 tbl, k1, p1] 9 times, k1.
>
> Rows 7, 9 and 11: Same as Row 5.
>
> Rows 8 and 10: Same as Row 6.
>
> Row 12: Same as Row 2.
>
> Row 13: Same as Row 3.
>
> Row 14: Same as Row 4.
>
> Rows 15, 17, 19, 21, 23: Knit.
>
> Rows 16, 18, 20, 22: Sl 1 purlwise wyif, p1, k to end.
>
> Row 24: Same as Row 2.

Key

RS: knit
WS: purl

◯ yo

⋀ CCD

／ k2tog

＼ ssk

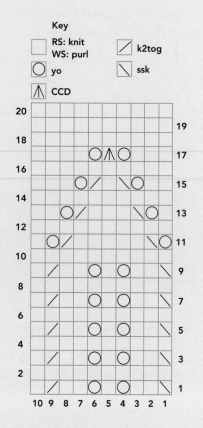

> Row 25: Same as Row 3.
>
> Row 26: Same as Row 4.
>
> Rows 27, 29, 31, and 33: Knit.
>
> Rows 28, 30, 32, and 34: Same as Row 2.

There's nothing wrong with these instructions, but it's hard to keep track of where you are.

A minor reorganization can help show the bigger picture:

> Row 1 (RS): Knit.
>
> Row 2 (WS): Sl 1 purlwise wyif, p to last st, k1.
>
> Row 3: Bind off 12 sts, [yo twice, k2tog] 12 times, k2.
>
> Row 4: Sl 1 purlwise wyif, p1, [p2, k1] 12 times, k1.
>
> Row 5: K1, [k1, p1, k1 tbl, k1, k1 tbl, p1] 9 times, k2.
>
> Row 6: Sl 1 purlwise wyif, p1, [k1, k1 tbl, p1, k1 tbl, k1, p1] 9 times, k1.
>
> Repeat Rows 5 & 6 twice more, and work Row 5 again.
>
> Work Rows 2–4 again.
>
> Row 15: Knit.
>
> Row 16: Sl 1 purlwise wyif, p1, k to end.
>
> Repeat Rows 15 & 16 three more times, and work Row 15 again.

Work Rows 2–4 again.

Row 27: Knit.

Row 28: Sl 1 purlwise wyif, p to last st, k1.

Repeat Rows 27–28 three more times.

Note that though Rows 27 and 28 are repeats of Rows 1 and 2, I've written them out so that the repeats are consecutive and the instruction is easier to find.

But there's more! To add to the fun, the designer had:

Rows 35–44: Same as Rows 13–22.

This doesn't (easily) work with the reworked instructions above, because Rows 13 and 22 aren't numbered, so we restructure again, to make it easy to identify the larger repeat.

Row 1 (RS): Knit.

Row 2 (WS): Sl 1 purlwise wyif, p to last st, k1.

Row 3: Bind off 12 sts, [yo twice, k2tog] 12 times, k2.

Row 4: Sl 1 purlwise wyif, p1, [p2, k1] 12 times, k1.

Row 5: K1, [k1, p1, k1 tbl, k1, k1 tbl, p1] 9 times, k2.

Row 6: Sl 1 purlwise wyif, p1, [k1, k1 tbl, p1, k1 tbl, k1, p1] 9 times, k1.

Rows 7–11: Repeat Rows 5 & 6 twice more, and work Row 5 again.

Row 12: As Row 2.

Row 13: As Row 3.

Row 14: As Row 4.

Row 15: Knit.

Row 16: Sl 1 purlwise wyif, p1, k to end.

Rows 17–22: Work Rows 15 & 16 three more times.

Row 23: As Row 15.

Rows 24–26: As Rows 2–4.

Row 27: Knit.

Row 28: Sl 1 purlwise wyif, p to last st, k1.

Rows 31–36: Work Rows 27–28 three more times.

The key difference between this and the first version is how we're articulating the sub-repeats.

All of the versions are correct, but please consider ease of reading and usability.

When There's Two

Do you need to tell knitters to make two socks or two sleeves? This is a point of debate and a style-sheet issue. Choose which way you want to do it and stick with it.

"Enjoy!" On Concluding Statements

Some designers like to conclude their patterns with a statement, such as:

"Weave in ends and enjoy."

"Wear with pride."

"Show off to all your friends."

Although always written with kindness and fun in mind, these sorts of statements can lose their appeal and tone in a written form.

If you do wish to use a concluding statement, keep it brief and make it part of your overall style sheet.

Consider using this as an opportunity to connect with your knitters, as in:

"Thanks for knitting! To see what else I've been up to, visit my website. I'd love to see pictures of your finished projects. You can email me at: <name@website.com>."

Charts

In This Chapter

Charts are an excellent way to express repeated pattern stitches. They're mandatory for colorwork, and are highly recommended for lace and cables.

Tools

There is a variety of software applications available to create charts, but you can do it perfectly well without special software.

The lowest-cost solution is to (neatly) draw them by hand, and scan the drawing. For a long time, I happily used Aire River's Knitting Font, a free downloadable font, in conjunction with a spreadsheet program. You can download the font here: http://home.earthlink.net/~ardesign/knitfont.htm.

XRX (the publisher of *Knitter's Magazine*) has also published a similar font, Knitter's Symbol Font, available for download here http://www .knittinguniverse.com/downloads/KFont/.

Install a font with knitting symbols, such as V into your word processor, spreadsheet, or layout software.

Many designers create their own charts in a drawing program such as Illustrator, but in many ways a spreadsheet program can be easier: stitches and rows can be automatically created, and grids are easily added and managed.

There are six major purpose-built solutions for creating knitting charts for publication:

ChartMinder
http://chart-minder.com/

Intwined Studio
http://intwinedstudio.com

KnitVisualizer
http://www.knitfoundry.com/software.html

Pattern Genius
http://www.patterngenius.com/

Stitch Maps
http://stitch-maps.com

Stitch Mastery
http://www.stitchmastery.com

Knit Companion, a tool from the maker of Pattern Genius, https://www.knitcompanion.com/ does allow the knitter to create charts, but it's intended as a tool for the knitter, not the designer. The charts generated aren't formatted or output in a way suitable for inclusion in a pattern.

Each offers similar core functionality; which tool is best for your own circumstances will often be a matter of simple preference or platform availability.

Chart Minder is a newer tool, but looks very promising. It is entirely online right now, and it was initially developed with a view to helping knitters create and manage colorwork charts. The developer says that she initially designed the software to help her with a project that she was working in colors different from those the designer used, but quickly realized it would be helpful to other knitters and designers. As of this writing, a second version is in development, broadening to other types of stitches, and enabling designers to create charts for embedding in their patterns.

Designer Melissa Leapman uses Intwined Pattern Studio, and says that "**Intwined Studio** allows me to create my own stitch symbols and is a fantastic feature. And the ability to custom-scale a chart image up or down is crucial for page layout." Anne Berk says, "I recommend Intwined as an easy-to-use program that gives professional results. Reliable, versatile."

KnitVisualizer was the gold standard for a long time, but given that it hasn't been updated since late 2008, it is falling behind in functionality. That said, it's easy to learn and use, and meets the vast majority of requirements.

Pattern Genius is a new but surprisingly sophisticated tool, with lots of great features for chart creation and editing, but is currently limited to iPad only—although the developer hints that she hopes to be able to support other platforms soon. It's particularly smart about copying and mirroring and building repeats within a chart, and the stitch symbols and the generated legends are very customizable. Designer Faina Goberstein says "Pattern Genius's ease of use allows me to

create high-quality charts very quickly. Their responsive and precise technical support is particularly helpful."

JC Briar's Web-based **Stitch Maps** takes a new approach. Although similar to the other programs in its objectives, its output is fairly different: Briar's approach is to show the shape of the fabric, so if there's a set of increases and decreases that causes the fabric to scallop (e.g., for feather and fan), then the lines of the chart scallop. Her charts don't have grids, and are similar to those common in crochet. Designer Lorilee Beltman says, "The Stitch Maps website is a tool that has streamlined my pattern-writing to the point that it's the only charting tool I want to use. The fact that I can swatch virtually means I can get many rejected iterations out of the way before ever putting needles to yarn. Exporting the map to my document is easy, and I can include horizontal lines to help the knitter keep their place." Lucy Neatby is an avid user: "Being able to position the symbols in a representative layout with no gaps makes designing a lot easier. I can sketch what I am aiming for directly onto the chart. I then superimpose colors and other details onto the charts with a drawing program."

Stitch Mastery is the newest of the traditional charting applications. It's immensely powerful and sophisticated in chart creation and manipulation, and it's my tool of choice. There's also a set of fonts that comes with the application. Designer and tech editor Donna Druchunas says that Stitch Mastery is her "go to charting software. The key is created with the chart and you can edit it on the fly. It includes a handy feature of hiding symbols or colors." Designer Hunter Hammersen says, "I adore Stitch Mastery and have used it in all my independently published books. I love how flexible and customizable it is."

Basic Format

No matter how you create your charts, your knitters will be happiest if you stick pretty close to the usual conventions.

Stitch Numbers & Row Numbers

Regardless of how big or small the chart is, including row/round numbers is mandatory, and for a chart that's got no repeats (keep reading for details on how to deal with charts that do have repeats), stitch numbers should be included, too.

If your tool permits, the stitch numbers are much better placed at the bottom of the chart rather than at the top. After all, it's working the first chart row that requires the most careful counting. There is one exception to this rule—see On Changing Stitch Counts and the No-Stitch Symbol, page 72.

Gridlines

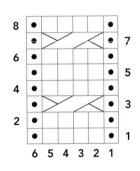

It seems utterly obvious, but you need to include gridlines in your chart—borders around each stitch. If a complex stitch covers multiple stitches in a row (e.g., a cable), then the gridline should outline the outside of the complex stitch only.

I saw a chart once that had been created on a gridded background, as in the sample below. Although it seemed like a good idea, enabling easier identification of the row numbers, there simply wasn't enough distinction between the actual stitch borders and the background grid, and the chart was hard to read. And on a lower-resolution display, or printed out, this distinction can be lost entirely.

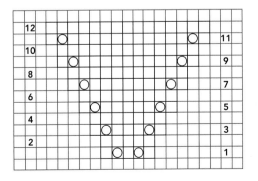

Symbols

Use established symbols for the stitches. Have a look at the symbols being used by magazines and other publishers.

Of course, there are a few different standards in use around the world. Consult a local publication, for a local audience; if you wish to publish for a global audience, using a North American standard is reasonable.

For the knit stitch, I recommend using a blank square rather than a vertical line, as it keeps the charts cleaner and easier to read.

For the purl stitch, I recommend a dash or dot. Some designers use a gray square for a purl stitch, but these can get confused with the "no-stitch" symbol, and things can go horribly awry if it's a colorwork chart.

What if there isn't a standard symbol for the stitch you're using? Make sure that there really isn't, first of all. This is where using a charting software tool can be helpful, as their lists of symbols are very thorough. Check pattern books to see if a similar stitch has been used. If you really need to, you can invent a symbol, but like inventing a stitch name, make sure it is sufficiently distinct and define it very clearly.

A Legend

It's surprising how often the legend for a chart is forgotten. The legend is not optional. No matter how standard or obvious the symbols are, you need a legend. This may well be a knitter's first chart-reading experience.

Define the symbols fully; if a stitch is worked on both RS and WS, provide both definitions.

When building the legend, knit and purl are typically the first items listed. In general, it's best to list the entries in order of size: all one-stitch symbols first, then multi-stitch symbols next (e.g., cables and wraps), in increasing order. You can go a couple of ways to order the symbols beyond

that: in the order in which the stitches are used in the chart (e.g., if ssk is in Row 1, and k2tog doesn't appear until Row 2, list ssk before k2tog in the legend); or in a logical grouping (e.g., list all decreases together, all increases together, etc.). It's up to personal preference. Again, consistency is most important.

If you have multiple charts, combine the legends into one.

If you're using a cable in the chart, or a more complex stitch that needs further definition, you've got two choices. You can include the definition in the chart legend, as in:

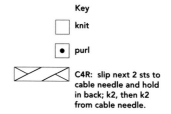

But it can make the legend a little unwieldy.

If you only list the name of the stitch in the legend, just make sure you remember to define it in the master glossary.

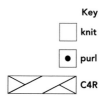

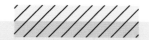

TYPOS I HAVE KNOWN

Designer Katya Frankel confesses she once wrote an instruction to slip stitches to "waist" yarn, thoroughly confusing knitters who thought they were working on a sleeve.

For Patterns Worked Flat

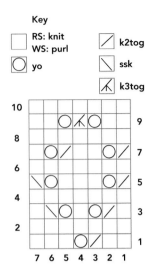

Put the row numbers for the RS rows on the right-hand side, and for the WS rows on the left.

For simplicity, stitches that are only worked on the RS only need a single definition in the chart key.

For Patterns Worked in the Round

Put all the round numbers on the right-hand side. Stitches only need a single definition because they're worked only on the RS. If at any point in the pattern the chart might be worked in rows—for example, on the heel flap of a sock, or in a section of short-rows, remember to include the WS definitions, too.

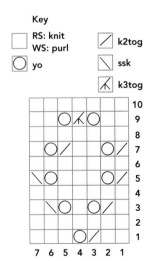

Show All Rows/Rounds?

If every alternate row is plain, and all are worked the same way—all knit or all purl, for example—and if you need to save space, you can consider removing all the alternate rows from the chart.

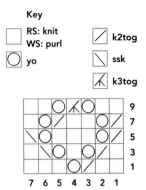

But don't forget to provide clear instructions for what to do on the even rows/rounds.

Charts with Repeats

The following chart can work over 8, 14, or 20 stitches—any multiple of 6 stitches plus 2.

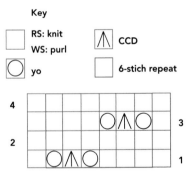

If the pattern stitch has a repeat, remove the stitch numbers, as in the chart above. To number the stitches could leave the knitter astray: If the far left column was numbered 8, then imagine a knitter trying to work this pattern on 14 stitches. When she hits the 8th stitch, does she begin the repeat again, or work the stitch in the column labeled 8?

It is helpful, though, to indicate the number of stitches in the repeat, either in the legend, as in the example above, or in the actual chart, as on page 72.

Key
RS: knit
WS: purl
CCD
yo
6-stich repeat

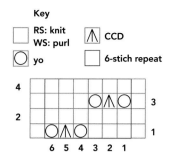

sometimes a gray square, or sometimes an *X*, or sometimes an *X* in a gray square. It's your choice which you use, just be consistent.

Key
RS: knit
WS: purl
CCD
yo
6-stich repeat
no stitch

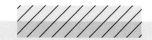
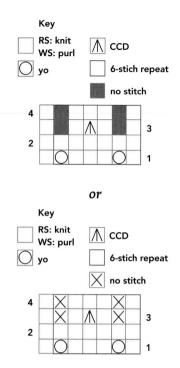

or

Key
RS: knit
WS: purl
CCD
yo
6-stich repeat
no stitch

BECOMING A BETTER PATTERN WRITER: Knit Other Designers' Patterns

Or at least read through them. Take notes on the experience. What you find difficult, confusing, or unhelpful will absolutely be difficult, confusing, or unhelpful for other knitters. What you find easy, fun, and helpful will be easy, fun, and helpful for other knitters.

If you see something you like, it's entirely okay to be shamelessly inspired by it. Don't steal content or graphic design, obviously, but if you see an element you like, there's no reason you shouldn't mimic it.

On Changing Stitch Counts & the No-Stitch Symbol

Some stitch patterns have variable stitch counts, so charting software tools offer a "no-stitch" symbol.

There are two types of situations that require use of such a symbol: where a repeat has shifting stitch count due to mismatched increases and decreases, and where the fabric is growing in width, as in a triangular shawl.

Stitch Count Changing in Repeat

In the first situation, the overall shape of the pattern stays the same, but you might gain or lose a stitch or two in an individual row. This is where the no-stitch symbol comes in handy. It's

Note that many knitters struggle with the "no-stitch" concept, so if the pattern is aimed at anyone other than experienced knitters, consider adding a few words to explain that the stitch count changes and how that impacts the pattern and the charts.

TYPOS I HAVE KNOWN

Autocorrect can play havoc with a pattern: Ruth Garcia-Alcantud says she's written patterns with instructions to "block the German before seaming," and she's included a detailed discussion of how much is an appropriate "Armhole Death…"

When the Fabric Changes Shape

In the second situation, the overall shape of the fabric is changing. You see this most often in a triangular lace shawl. In these situations, it's clearer if you don't include a "no-stitch" symbol.

If the sides are shifting out, place the row/round numbers at the edges of the rows; it's easier to read.

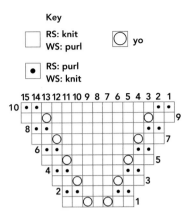

Since the increases are worked inside the borders, you can also stack the borders vertically, if you prefer, as in:

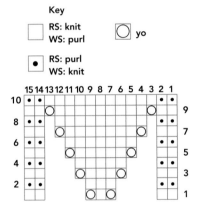

In both of the chart examples above, note that the stitch count is at the top, to indicate the target count once the chart is complete.

Of course, if there's a repeat, the numbers should be removed, as in:

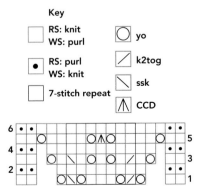

BECOMING A BETTER PATTERN WRITER: Make & Keep Detailed Notes on Your Design

The better your notes are, the better your instructions. You might think you'll remember that you had to adjust the start of the round after you turned the heel of the sock, but trust me, you won't when it comes time to write the pattern.

Designers are always making small adjustments on the fly, and you need to keep track of them to write an accurate pattern. Notes also help you remember if you used any special techniques that need to be explained in the pattern.

Keep the notes on file in case you get questions on your pattern from knitters or your technical editor.

If it's a triangle shawl with central increases around a spine element, it is helpful to show the spine and borders vertically. See chart below.

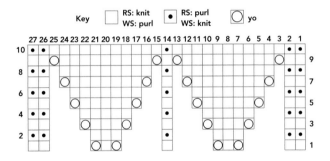

Colorwork Charts

Most colorwork charts are worked entirely in stockinette stitch, so the symbols are used to convey colors rather than stitch types.

There are two possible approaches: use the colors worked in the sample or change the colors to be "generic," to permit easy substitution. It's the designer's choice. Don't forget to include appropriate legends, of course.

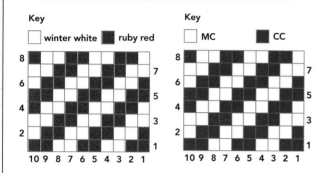

In either case, consider knitters who might be printing the charts in black and white or might be colorblind. If there are multiple colors, do a test print to make sure they are sufficiently distinct when printed in grayscale.

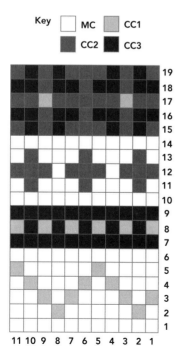

If there's a specific stitch to be worked (e.g., an increase or a decrease), then note it in the legend. If it's worked in one color, help your knitters out and list the stitch symbol in that color.

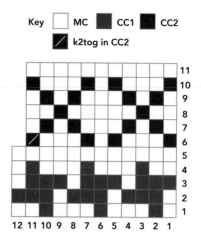

If it's worked in multiple colors, add a note to the legend, such as "work in color indicated."

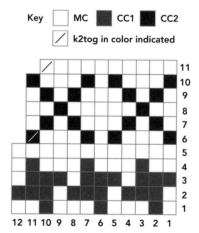

TYPOS I HAVE KNOWN

There was the infamous "safety pint." It was in a lace pattern, a shawl for beginners. I often suggest that until the pattern is clearly established, knitters put a safety pin in the RS of the fabric so they can more easily identify RS from WS. My tech editor, who has a well-developed sense of humor, suggested that if the knitter needed to have a beer on hand, it perhaps was more difficult than I intended.

Making Charts Easier to Read

If the chart is particularly large or complex, a few enhancements can help your knitters.

If there's a long stretch of stockinette stitch, borrow a tip from the Shetland lace knitters and put a number in the chart row to aid in counting that stretch of stitches. Just make sure you explain the significance of the numbers.

For example, in the following chart, I've placed stitch counts in Rows 1 and 11, where longer sections of stockinette appear.

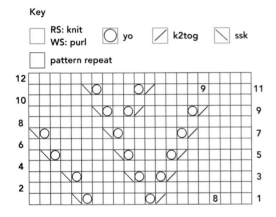

If there's a lot of stitches, use heavier gridlines to aid counting, and consider reducing the frequency of the stitch labels to every fifth stitch.

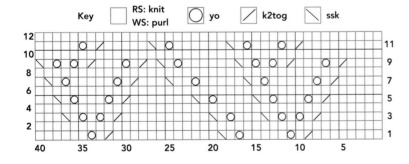

And if the pattern is heavily cabled with many different cable turns, adding color to the cables can help the knitter distinguish them. Again, though, consider those who might be printing in black and white and knitters who may be colorblind.

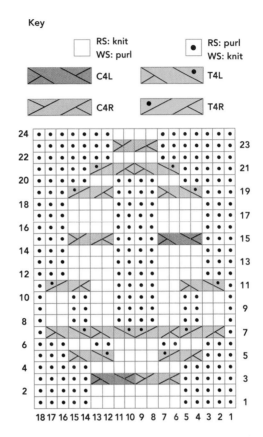

Grading

In This Chapter

What & Why

Grading is, in short, the scaling of a pattern to multiple sizes. Grading is often one of the biggest challenges of knit design.

A lot of designs only need to come in one size—items such as scarves, blankets, shawls. Other items can come in multiple sizes, but those sizes are essentially arbitrary, or are pre-determined by external criteria—such as a baby blanket sized to fit a car seat versus one to fit a crib.

But when an item is a garment that is to fit, and you wish to offer multiple sizes, then the pattern needs to be graded—each size needs to differ from the others proportionately.

You don't necessarily need to grade your garment pattern. It's better to have one size that fits well and is flattering and well-constructed than it is to guess about other sizes. Including more sizes does provide a larger possible market into which you can sell your pattern, of course, but if five of the six sizes aren't great, then 5/6 of the finished sweaters aren't going to be great.

And remember: If you are doing just one size of a garment, it's still a specific size that needs to be articulated fully and properly. See Size, Measurements & Schematics on page 22 and One Size Fits All on page 24. Be honest and clear about how that size fits, and knitters will have no grounds for complaint.

How

Grading is a two-step process: first decide whom you wish to fit, and then decide how the garment should fit those people.

You must answer questions such as: Are you making a sweater for babies and toddlers? How small is the smallest baby you wish to fit, and how old a toddler do you wish to cover? Does your size range include typical newborns to one-year-olds? Or preemies to two-year-olds? For adults, what chest measurement range are you looking to fit?

And then how is the garment to fit those sizes? That is, if you're making a garment for men that is to be worn with about three inches of positive ease in the body, what body sizes do you need to include?

These are very different questions, and they likely have very different answers.

Whom to Fit

If you're making a sweater and you want it to fit men of chest measurements 36, 38, 40, 42, 44, and 46 inches (91.5, 96.5, 101.5, 106.5, 112, and 117 centimeters), then for each of those sizes you need to know all the key body measurements for an average person of that size—chest circumference, armhole length, underarm-to-waist distance, shoulder width, arm length from shoulder, etc.

If you're fitting to a specific person, you can measure that person. If you want to fit to a range of people, then you need resources to tell you what sizes they are, on average.

The Craft Yarn Council (CYC) of America publishes a set of standard body measurements, available online and in a downloadable PDF, that can be very useful.

Craft Yarn Council Standard Body Measurements/Sizing
http://craftyarncouncil.com/sizing.html

For babies, children, women, and men, they provide a set of standard body measurements: chest, waist, and hip circumference; waist and hip length; cross-back width; arm length; armhole depth; and arm circumference. They also provide foot and head measurements, although there are better resources for those (discussed later in this chapter).

The CYC measurements are a great place to get started, but if you're creating many garments for many sizes and are working at a professional level, I highly recommend you work from more detailed and more thorough measurements.

The American Society for Testing and Materials
(ASTM) has published significantly more detailed data sets. To give you a sense of the level of detail, they list circumferences of head, neck base, mid-neck, shoulder, chest, under-bust, upper chest, waist, high hip, low hip, seat, thigh, mid-thigh,

knee, calf, ankle, armscye, upper arm, elbow, wrist, hand, and a similar set of numbers for length measurements, covering a wide range of shapes, sizes, and body types.

Some of this information is excerpted on the ASTM website, and full reports are available for a fee, between $40 and $50 each, for a given gender/age category.

American Society for Testing and Materials
http://www.astm.org

Many designers also maintain their own size data, created from a combination of published sources and their own experience. Designer Eileen Casey has generously published a set of data on women's, men's and children's body measurements, gathered from a number of sources http://www.eileencaseycreations.com/measurements/. You can download spreadsheets and use them as the basis of your own data.

FOOT SIZE

The Craft Yarn Council does offer measurements, but the range is too broad to adequately size sock feet. In 2011 and 2012, I ran a survey about foot size, and published the results on the Knittyblog.

"Foot Sizing Survey Results"
http://knittyblog.com/2012/07/foot-sizing-survey-results-contest

A more detailed summary of this survey can be found in my Interweave book on custom-fit socks.

HEAD SIZE

Designer Kate Oates has published an excellent head-sizing chart on her website and in her "Math For Hats" booklet, also available for purchase at her site.

Tot Toppers Sizing Chart
http://www.tottoppers.com/sizing/

How to Fit

Once you've determined the size(s) of people you want to create your garment for, you need to figure out how you want the garment to fit those sizes. If you want 3 inches (7.5 centimeters) of positive ease in the body to fit men of chest circumferences of 36, 38, 40, 42, 44, and 46 inches (91.5, 96.5, 101.5, 106.5, 112, and 117 centimeters), then the finished chest measurements should be 39, 41, 43, 45, 47, and 49 inches (99, 104, 109, 114.5, 119.5, 124.5 centimeters). And for each of those sizes, you need to work out how deep the armhole should be, how long the garment should be from the armhole, and so forth.

Yup, this is pretty complicated, and add to this the fact that ease should scale with body size. An adult garment worn with two to three inches (6–7.5 centimeters) of positive ease looks comfortable but still fairly tailored. A baby sweater with two to three inches of positive ease looks positively oversized.

Also, understand that ease must vary throughout the garment: a sweater with three inches (7.5 centimeters) of ease around the chest will typically have only one to two inches (2.5–5 centimeters) of ease in the sleeve. It's proportionate: the smaller the thing that's been wrapped, the less ease is required.

Obviously, it's easier to start your grading adventures with accessories. Items such as hats, mittens, socks, and leg warmers are easier to handle, because you're not fitting to as many different places in the body, and the ease question is less complicated: for these types of items, the ease is typically consistent throughout.

Ease should be relative, rather than absolute. Consider a glove. You might expect the wrist and the palm to have about the same amount of ease—if the wrist is about three quarters of an inch (2 centimeters) smaller than your actual wrist, then the palm would be the same. This makes sense because the wrist and the palm are relatively close in size. But for fingers, it works differently. If you're designing for a hand with a 7-inch (18-centimeter) palm circumference, three quarters of an inch is just about 10 percent of the full circumference, so you're making a mitt that stretches about 10 percent to fit snugly but not tightly. But if you look at the little finger, which is about 2 inches (5 centimeters) around, three quarters of an inch is nearly 40 percent of the circumference; ease to that degree would make the fingers very tight and uncomfortable to wear.

What you want is the finished glove fingers to be about 10 percent smaller than the actual fingers they are to fit, just as the palm and the wrist portions are about 10 percent smaller.

Put differently, you should calculate ease relative to the size of the body part: if it's 10 percent of the circumference in the palm, it should be 10 percent of the circumference in the fingers.

You can learn a lot about fit and required ease by analyzing other patterns—how much ease is there at various places in the construction?

Note that a good technical editor may well be able to grade a pattern for you—just ask. See Technical Editing on page 90 for more information about tech editors and what they do.

That's Not Grading

Telling a knitter to work to a different gauge or to change needles to alter the finished size of an item *is not grading.*

It's true that if you use thicker yarn and larger needles than specified in the pattern, the finished item will turn out to be larger than indicated in the pattern (or smaller yarn/needles for the reverse effect, of course).

And if the item is a square or rectangle, and it doesn't need to come out to specific measurements, then this strategy is mostly harmless. Indeed, some patterns do offer multiple sizes/versions that rely on this, precisely.

But *this approach isn't grading,* and the minute that you need to start thinking about shaping, or seaming, or other construction details, then things can start to go awry. If you're setting a sleeve into an armhole, for example, the success of the construction requires the width of the sleeve top to fit neatly into the armhole—changing gauge means that you risk the pieces not fitting together. And if your pattern includes an armhole shaping that's a combination of rows and lengths, as in:

> **Bind off 3 sts at the beginning of the next four rows, then 2 sts at the beginning of the following 6 rows, and work even until the armhole measures 9 inches (23 centimeters),**

RESOURCES

Articles

"Multisize Me: Grading a Knitting Pattern for Multiple Sizes" by Jenna Wilson, knitty.com Spring 2008. Available at: http://www.knitty.com/ISSUEspring08/FEATspr08TBP.html

Books

The Knitter's Guide to Sweater Design, by Michelson & Davis. Out of print, and used copies tend to be fairly expensive, but you may be able to track it down at your local library.

Sweater Design in Plain English, by Maggie Righetti.

Knitwear Design Workshop, by Shirley Paden.

Little Red in the City, by Ysolda Teague.

Fit to Flatter, by Amy Herzog.

Big Girl Knits, by Jillian Moreno and Amy R. Singer.

(See the Appendix for full information on the books, including publisher and ISBN numbers.)

then you're going to get an armhole that's 9 inches deep no matter how big or small the yarn that the knitter uses. The fix here is to grade properly: figure out the length required for the other sizes, rather than relying on the yarn to make it bigger or smaller.

Further, because knit stitches aren't square to begin with, scaling isn't straightforward.

If the pattern calls for yarn at the gauge of 28 sts and 40 rows per 4 inches (10 centimeters), and you are to cast on 28 stitches and knit 40 rows, you'll get a piece that's 4 inches by 4 inches. But if you change to a yarn that works to a gauge of 20 stitches and 26 rows, and you cast on 28 stitches and work 40 rows, you'll get a piece that's 5.6 inches (14 centimeters) wide and 6.15 inches (15.5 centimeters) long. That piece is 1.4 times the original width, but 1.53 times the original length—meaning that it's not growing proportionally in length and width.

ADVICE FROM AN EXPERT: Designer Ruth Garcia-Alcantud

I chatted with knit designer and tech editor Ruth Garcia-Alcantud about the grading problem, and how to go about solving it.

How did you learn to grade?

It was a mix of skills, really. My grandmothers were both experienced seamstresses, my father worked in fashion, I learned to knit and sew from an early age, and you really do learn a lot about grading when working with woven fabric. When I started designing knits, I applied some of that. I got my ASTM full set and did some tweaks on it. Then I asked friends with different heights and sizes as well as body mass distribution to help me see if my ideas were good or not.

It's still a job in the making. I still make notes on that master sheet. I still add things, and have learnt with every pattern.

Are there resources you would recommend to help others learn? Books? Online classes? Classes at local colleges, maybe? I took a class at my local college in the Fashion Design school.

Practice. I'd ask friends to let me measure them. I have read and re-read Shirley Paden's book (on your resource list) obsessively and it's a book I keep within arm's reach of my desk. I kept making mistakes, trying to make a square peg fit into a round hole, basically! If you are lucky enough to have a grading class available to you, take it—just ensure they want to cover knits, and not wovens.

Biggest mistake a newer designer makes?

Going too fast too soon. It's easier to begin with a garment that has little to no difficulty. While designing a sweater in pieces in stockinette may make you cry, you can learn a lot from the fabric and your numbers. Take all the learning in, because when you bring in cabled pattern repeats that only allow you to grade in four-inch increments, and you also have to match the sides, and deal with complex neckline shaping… you better know your basics!

And I've seen many designers forget that seams consume stitches: Let's say you have a garment graded at 4 sts per inch (2.5 centimeters). You think, "My front and back pieces need to measure 18 inches (45.5 centimeters) for a garment that fits a 36-inch (91.5-centimeter) bust." Let's analyze this:

> 18 inches (45.5 centimeters) x 4 sts = 72 sts.
>
> 72 front + 72 back = 144 total, BUT when it comes time to seam, your seams will take 2 sts off each front and back. 144 - 4 seam sts = 140.
>
> 140 / 4 sts per inch (2.5 centimeters) = 35-inch (89-centimeter) final measurement.

What are your favorite tools for grading?

While you may think my spreadsheet app (Numbers for Mac) may be my first port of call, I tend to think and outline on paper first! I draw my schematic first of all, and plug in some guideline numbers to start with, and I swatch with that in mind. For some reason, having that paper in front of me helps me to create my spreadsheets and figure out the roads to take. Also, practice quick math in your head: a fast and limber brain is of great help!

Other words of advice?

The more you know, the better you will become—practice your grading. It's your homework. Try to understand why a designer may have made a certain choice when grading: Ever seen a garment that is graded in increments of 3.75 inches (9.5 centimeters)? Why was that? Check the difficult areas of that pattern and try to apply your designer brain to it!

Reverse engineer your own old patterns—can you make them better?

Learn to love gauge. Not everything can be solved by "pick up 2 sts per every 3 rows."

Don't lock your ideas to a certain style of construction. Not everything looks better with seams (even if I love them so!) and not everything is meant to be worked in the round.

An even more dangerous approach is to simply tell the knitter to use the same yarn, but change the gauge of the fabric by using smaller or larger needles. This sends a very clear message that you don't care about the qualities of fabric: the same yarn worked on different needles creates different fabrics. This approach is seen far too often with socks, where fabric density matters enormously. A sock yarn worked at 30 stitches in 4 inches (10 centimeters) is nice and dense—not so tight that it's hard to knit, but tight enough that it wears well and feels good underfoot. Working the same yarn more tightly can make for an unpleasant knitting experience, and working more loosely will mean that your socks won't be as durable.

For garments, this approach just doesn't make sense—the finished items will look significantly different at different gauges. *Grading is simply a requirement.*

Formatting & Layout

In This Chapter

This is a very broad topic, clearly. Graphic designers go to school for years to learn good layout skills. If your budget permits—or if you've got the software and skills yourself—a professional layout job will always look great.

That having been said, with some simple tools and simple guidelines, you can create attractive and usable patterns without hiring a professional. This chapter is not intended to replace graphic design training or the services of an expert, but it should at least give you enough knowledge to talk to a graphic designer, or set you on the way to improving your own skills.

No matter how you achieve it, a tidy, well-thought-out layout is critical. It doesn't have to be fancy, but it has to look good. Access to computers is pretty much universal, and expectations about pattern quality are higher than they have ever been. Hand-written, hand-drawn or "unformatted" documents are simply not acceptable any more.

Software

Many graphic designers use a layout tool like Adobe InDesign, but even the most mainstream of office suites includes some kind of layout software. Classic word processors like Microsoft Word offer sufficient functionality to create a nice and tidy pattern. Essentially, all you need is the ability to embed an image, change text fonts and sizes, make text italic and bold, and add a second column.

Google Docs and Open Office are free solutions that are remarkably powerful.

It's better to stay with a program you know well than to spend a lot of money on software like InDesign and struggle to use it.

Output Format

No matter what tool you use to create the files, when your aim is digital delivery, be sure to render the file as PDF (which stands for Portable Document Format). The Macintosh platform provides native functionality for this, and

there are various software tools that add this functionality to Windows. Many printer drivers provide it. Of course, Adobe Acrobat or any of the Creative Suite programs offer this as a feature. PDFs are easily viewed on any type of platform and device—Windows, Macintosh, iPads, Android.

In addition, PDF files are relatively protected, so that the user can't inadvertently modify or edit the file while viewing it. Many years ago, I bought a pattern that was delivered to me in .doc format—which was editable. I was looking at it in MS Word, and accidentally deleted the chart images.

Many PDF viewing solutions offer markup tools that make digital-viewing of the file better: highlighter tools, annotation tools, zooming capability.

PDF works perfectly, too, if all your knitter wishes to do is print the pattern to work from it on paper.

Make sure, of course, that you maintain the original file in an editable format so you can revise it as needed. Although it is possible to edit a PDF, it's neither easy nor fun.

Layout Guidelines

As with so many things, the rule is this: Keep it simple. A plain document with a single font, and next-to-no formatting will always look more elegant and professional than a busy layout.

Just as you did for the pattern instructions, you want to create a style sheet for the layout, too.

Keep the fonts simple: Leave the fancy, flowery, curly ones for titles and headings if you must use them. Make sure the type is easy to read—look at it on your computer monitor, but also print it to see how big it is on the page. Keep the type a decent size; the average adult struggles to read anything smaller than 10pt text. Be sparing with bold, italics, and underlining; use them only when you truly want to draw attention to something—it can't all be the same level of importance.

Establish a visual hierarchy: Define styles for your different levels of heads, and use them

consistently. Your pattern name will be a big heading, your name is a secondary heading. The various sections, SIZE, PATTERN NOTES, MATERIALS, METHOD should all have the same heading size/format. Subheadings, like Yarn and Needles in the MATERIALS section should be the same, and be smaller than the MATERIALS heading.

Be consistent: For example, do headings have a colon after them, or not?

On the first page: Include your main project photo, a high-level description, and the size/measurement information. This is your glamour page. It's OK to use a large photo here, or a medium-sized photo with smaller photos that highlight your pattern's details.

Be conscious of page usage: You don't need to cram your pattern onto two pages if it barely fits; better to enlarge the font a little and let it spill over to a third page. But filling only a small part of the additional page looks unprofessional. If your text only takes up a few lines—less than a third of the page—add some extra photos: detail shots of the patterning or construction details, for example. Remember to number your pages.

Be careful about using color in instructions and charts: Not everyone has access to a color printer and some knitters are colorblind.

Do not use patterned or colored background for text: These can be hard enough to read on a screen, and can often get completely blacked out in printing.

Don't mix instruction, tutorials, and references: A knitter will always need the first, but might not need the other two. If you have extensive and picture-heavy tutorials or references, gather them all together. Don't make your knitters print it all if they don't need to. Unless the point of your pattern is having a photo tutorial, keep the instructions pages light on pictures and graphics, so that they can be quickly and easily printed.

Consider using a two-column layout: This works particularly well if you've got quick tips and stitch definitions, or a little bit of editorial to describe the purpose of a step; put the instructions on the left, and the supporting information on the right. This keeps the overall flow of the instructions clean and easy to follow. Using multiple columns can also reduce your page count if you are tight on space.

Give special attention to charts: Keep the charts together, and keep the chart legend on the same page as the charts. If you've got multiple chart pages, include the legend on every page.

ADVICE FROM AN EXPERT: Knitter & Graphic Designer Zabet Groznaya

Don't use clip art; save that for kid's birthday cards and yard-sale signs. A cutesy graphic only makes your pattern look unprofessional. If you simply must use a piece of clip art that you've found, remember that using it once is enough; you don't need to bookend your title with it. Nothing screams "unprofessional design" louder than mistaking symmetry for balance. If you have a logo that you want to use on your all patterns, be consistent about its placement.

When in doubt about fonts, go conservative. Times New Roman, Arial, and Helvetica may be boring, but they are clean and easy to read. Many years ago I made a pattern

in an all-cursive handwriting-style font because I was so charmed with it at the time, but now I look at it and realize it's impossible to read. *What was I thinking?*

Remember to check the letter "l" and the numeral "1" once you do settle on a font. Sometimes the lowercase letter l and the digit for the number one are the same or very, very similar. You can imagine how this might wreak havoc with knitting instructions; just choose another font.

If you need more space on a page, don't reduce margins down further than a quarter inch (.25") (6 mm). Printers have different minimum margin amounts that they need, and this will assure it prints well for everyone.

Do a Test Print

Before you publish, always do a test print. Do several test prints, in fact:

- in color
- in black and white
- at the lowest-quality setting your printer permits

Make sure everything is legible in all these versions. Are the pictures crisp and clear? Charts large enough to be easily read? Individual chart symbols clear?

Learning More

Layout & Design

Look at other knitting patterns and books. What do you like about them? What don't you like? What do you find easy to read?

Other types of instructional books can be helpful for layout ideas, too: cookbooks, other types of crafting books, instructions for furniture building or home improvement activities.

The e-book *Practical Typography* by Matthew Butterick is an absolute gem of a resource. Butterick, a writer, typographer, and lawyer, is fun to read, makes typography friendly and accessible, and is enormously insightful, making this a valuable resource for total layout novices. Even if you think you don't have time, or that you're not qualified to read about it, or that you have too limited experience with typography, it's useful and easy to read. It is available in its entirety online and for free.

Practical Typography by Matthew Butterick
http://practicaltypography.com

If you do nothing else, at least read this page; you'll learn some important things:

Typography in Ten Minutes
http://practicaltypography.com/typography-in-ten-minutes.html

ADVICE FROM AN EXPERT: Knit Designer & Graphic Designer
Elizabeth Green-Musselman

My main tip for placing photos, charts, and other graphic elements in Microsoft Word is this: Set the Text Wrap to "Behind Text" so that you can move the graphic element anywhere on the page you like.

Fonts can be problematic. Use no more than two (maybe three if you really know what you're doing), for the love of all that's good and holy.

In addition to the "too many fonts" problem, there's also the "atrocious font" problem. MS Word comes with some excellent fonts (Caslon, Garamond, Palatino, and Georgia being good examples), and many really hideous and/or overused ones (if you ever use Comic Sans, I will personally come over and thump you on the head with a niddy noddy). To give a more unique look to your pattern design, try the website fontsquirrel.com, which is a well-curated collection of free fonts. And just pick one fancy font. It's all you need and you can use it sparingly.

I also strongly recommend breaking up your text into two or three columns on the page. This will save you a ton of space, make your patterns easier to read, and give them a more professional look.

Software & Tools

Lynda.com is a subscription service for online instruction videos. The selection is extensive, and there are in-depth courses on specific software programs, graphic design, book layout, and more. You pay a flat monthly fee, so to keep the cost minimal, find a time when you can watch a whole bunch of videos one after another.

Lynda.com
http://www.lynda.com

The *For Dummies* series of books are generally very good, too. They're practical, sensible, and entirely accessible.

When Not to Format

If you'll be submitting the pattern to a publication, don't do any layout. Check the publication's style sheet requirements, of course, but if there aren't any specifically about layout, you won't go wrong by keeping the pattern as clean and "layout-free" as possible. See Submitting to a Publication on page 91.

Use the following guidelines to keep things clean.

- Use one font only.

- Keep your use of bold and italics to a minimum.

- Don't use "system" (that is, "automatic") formatting—these sorts of things often get mangled when the file is opened with different software. For example:

 - Don't put text in headers and footers.

 - Create bulleted or numbered lists manually, with numbers or dashes.

The Process

In This Chapter

Okay, so you've designed and knitted your fabulous piece, and you've written up the pattern. What comes next?

Test Knitting

A test knitter makes sure that your instructions work—that is, that following your instructions produces the item as shown in the photograph. Test knitters often work with draft versions of a pattern, and you should expect a lot of communication. The objective is that the test knitters ask questions about instructions that are unclear, identify problems with the pattern, and communicate their experiences with the knitting process. If, due to a typo, the front of the sweater is two inches longer than the back, you should expect to hear from your test knitter about it.

There are two types of test knitters: those who test the instructions, and those who test the finished object. The first type of testers are, ideally, less-experienced knitters. I recently published a lace shawl with a chart-reading tutorial. I enlisted knitters who weren't confident about using charts to work through the pattern, to get their feedback on whether it helped them. A novice knitter (or a knitter simply less experienced with that type of pattern) will help you identify whether the instructions are clear enough, whether special techniques are sufficiently explained, and whether there's any information missing.

The second type of testers should be more-experienced knitters. I used test knitters recently for a sock pattern with an unusual construction to try out all the different sizes, to make sure each fitted well. These types of test knitters tend to focus on the result of the process and can't always be relied upon to test the instructions step by step. For example, if you forget to leave off the instruction to join the work in the round in a hat pattern, an experienced test knitter may simply not notice, or just make an assumption and proceed without being aware of it.

Test knitters of either sort may supply their own yarn for the test, or designers may supply it for them; the usual expectation is that the test knitter will keep the finished item, but the designer may well borrow it to photograph or examine it. (Note: You never charge the test knitter for the price of pattern.)

If you are using a test knitter, make sure you agree up front about the following things:

- Communications (how they are to contact you)
- Deadlines
- Who provides yarn
- Compensation (or not)
- Ownership of sample

Technical Editing

A technical editor is an experienced knitter and is often a designer in his or her own right. A technical editor reviews your pattern—without knitting it entirely—with two objectives in mind: to ensure the pattern can be knitted, and that when knitted, the pattern produces what it says it will.

Can It Be Made?

The technical editor will check, first of all, that the pattern contains all the required elements:

- **Key pieces:** Required yarn and needles, gauge information, size and finished measurements, glossary, instructions, and so forth.
- **Complete instructions:** Did the designer remember to include the instructions for seaming and for knitting the buttonband, for example? If the pattern refers to a cable pattern, is it given and defined?
- **Thorough yarn details:** The name of the yarn, accurate and complete yardage and fiber content information note about whether the yarn still on the market.
- **Complete notions and needles list:** If the pattern involves cables, did you remember to include cable needle in the notions list, etc.

And then the tech editor will check to be sure that what's there makes sense, keeping an eye on the following sorts of things:

- **Do the yarn requirements seem reasonable?** (Can you really make a pair of knee-high socks with 400 yd [366 m] of fingering-weight yarn?)

- **Does the gauge seem right for that yarn and those needles?**

- **Are right types of needles called for?** (Circulars for working in the round, a 16-inch [40.5-centimeter]circular rather than a 24-inch [61-centimeter] for a small adult hat, etc.)

Then they'll check to make sure that the instructions are clear and correct:

- If the pattern is worked in the round, does it remind the knitter to join to work in the round?

- Does it include definitions for any special increases or decreases used, and do the definitions make sense?

- Are all the pattern stitches defined, in chart and/or written format?

- Are instructions or references for any special techniques provided?

And then they'll check that the math is right:

- Metric/imperial conversions are correct.

- The schematic shape matches the garment, and the measurements given match the pattern.

- The instructions produce the pieces of the size they say they do. (If you CO 80 stitches, what size piece is that at the given gauge?).

- The stitch counts listed after a set of increases or decreases are correct.

- If there's a set of shaping rows, that it fits into the length indicated. (If the instructions for neckline shaping say to decrease 1 st at the neck edge every RS row 12 times, and then

work even to 4 inches [10 centimeters], is the length of the 12 decreases less than 4 inches?)

What Does It Make?

The technical editor will also check the following sorts of things:

- The description of the finished item makes sense.

- The pattern stitches listed produce the fabric shown in the photos.

- If there are seams to be sewn, that the pieces fit together.

- The sizing makes sense for the garment type, size and fit. (Is a 9-inch [23-centimeter] armhole a good size for a man's fitted vest with a 44-inch [112-centimeter] finished chest?)

Working with a Technical Editor

Some technical editors will also help with grading and with creating schematics, and some even do layout. Ask!

You should expect to pay well for this sort of specialized work, and a garment pattern can easily take two to three hours to edit. Costs may be higher with your first few edits, as you build skills and work on your style, but as you get more proficient, the process will get faster.

"BUT HOW DOES IT MAKE YOU FEEL?"

Designer Lynne Sosnowski on Working with a Technical Editor

"A good TE is like a good therapist, in that you may have to try one or two before you find one that's the right fit for you, and who gives you the feedback you need in a way that you're able to hear constructively."

Working with a technical editor will help you develop your own style and help make your patterns more consistent. And working with the same editor long-term will also make the process more efficient, through consistency of communications.

If you have a style sheet, share that with your tech editor before work starts. One of my clients prefers to spell out "stitches" rather than use the common abbreviation "sts." Another of my clients doesn't capitalize the initial instruction of a row. Knowing those things up front saves a lot of editing time and back-and-forth.

If you are using a technical editor, make sure you agree up front about the following things:

- **Whether they need to have the physical samples, or if photos are okay.**

- **How they are to contact you, how to deliver feedback (e.g., comments in the document), how to handle revisions to the document.**

- **Deadlines.**

- **Compensation.**

Which Should You Use?

Test knitting and technical editing are closely related, and there is definitely overlap between them, but they do differ. On one hand, a good and experienced technical editor is always going to be more thorough than a test knitter. On the other hand, a pattern review by an utter novice is always valuable if you can find one, and is likely to uncover usability issues that a technical editor

might not notice. I had a recent pattern reviewed by a novice test knitter, and she pointed out a very simple problem that no one else had noticed: that I was referring to sock yarn without being clear that what I meant was fingering-weight yarn.

If you're self-publishing, a technical edit is mandatory, a test knit less so. If you're submitting your design to a publication, then a test knit is the more important of the two. For more on this, read on to the next section.

Don't Just Take It From Me

A lack of good editing such as mistakes in the instructions or charts, or lack of detail in the overall instructions, is **extremely** frustrating! I recently signed up for a class where the instructions and charts did not include the edge stitches for a shawl, and the only reference to the edge stitches was in the introductory text.

Sample Knitting

Sample knitting is when you need one of the items made up for display or photography purposes, in addition to the sample you made when working up the original design. Sample knitters expect to be provided with the required yarn, and are often paid or compensated in some other way. The standard expectation is that a sample knitter will knit the piece with materials and instructions you provide, then return the piece to you. A sample knitter will expect the pattern to be complete and correct, and will work it as written—and so if, due to a typo, the front of the sweater is two inches longer than the back, you should expect the sample to come back to you that way. Although an attentive and experienced sample knitter may well contact you with questions, this isn't their role.

Some designers return the sample to the knitter after an agreed-upon period, as (part of) their compensation.

Be realistic about charging for a pattern. I will happily pay $10 for a pattern that is tech-edited, has polished graphics and schematics, used a professional or highly skilled photographer, and is well written. It makes me less excited when I am asked to pay for patterns that don't have good photography, don't use a model, are not unique or original, or are so basic I could have designed them myself. I would go so far as to say that a pattern should not even be available unless it has been test knit by several other skilled knitters.

If you are using a sample knitter, make sure you agree up front on the following things:

- Deadlines.
- Who provides the yarn.
- Compensation (if any).
- Ownership of the finished sample.

You can find sample knitters through Ravelry, your local yarn shop, or referrals from other designers. Before you hire anyone, though, I highly recommend that you look at their work, to get a sense of their skill level and the quality of their work. Again, Ravelry is very helpful for this—have a look at their projects.

Self-publishing

Readying for Publication

As I mentioned above, if you're self-publishing, have your pattern reviewed by a technical editor. Get a friend or family member to proofread it, too. A non-knitter is more likely to focus on things such as whether you spelled your name wrong, if the layout is clear, and if the introduction is attractive and interesting.

Do the best job you can on layout, or hire a graphic designer to do the layout for you. And remember to export the pattern to PDF for digital distribution. For information on selling the pattern online, see Chapter 7: Selling Online, on page 96.

After Publication

Support the pattern. Respond to questions and if a mistake is found, update the pattern and republish. Be sure to also update the version number so you and your knitters can make sure they are working from the most recent and accurate one.

Both Ravelry and Patternfish allow you to upload a revised version of a pattern, and Ravelry has a feature that allows you to send the new version out to all who have purchased it. Make use of this.

Add notes to the pattern addressing the mistake, and address the change on the pattern page on Ravelry, also. If you've got a blog, put it there, too.

Knitters understand that designers are human and mistakes happen. They're amazingly forgiving when something goes wrong—as long as you own up to it and address it.

You can also expect to get questions about things that aren't mistakes. It's sometimes just stuff that knitters need help with (e.g., you mention the Twisted German cast-on, is there a good video that shows how to do it?) or clarification on (e.g., the slipped stitches at the start of the rows—should they be slipped knitwise or purlwise?).

If you find you're getting a lot of questions about a particular topic, consider writing a blog post, or even updating the pattern, to address it. See Monitor Your Ravelry Pattern on page 101 and Stalk Your Patterns on page 102 for more information.

Submitting to a Publication

If you're submitting to a publication, then the pattern-preparation process is a little different.

There are two types of submissions: some publications take a complete pattern, others want a proposal first.

The Proposal

The publication will be specific about what their requirements are for what to include. Typically, they will want a detailed description of the item

ADVICE FROM THE EXPERTS:

An editor who wished to remain anonymous made a really important point

"When you bad-mouth an editor online it always gets back to us. We are human, too, and there is no need to be cruel or disrespectful, especially in an industry that brings so many people so much joy."

Editor of *Knittyspin* magazine, Jillian Moreno

"Photography and passion for what a designer has created will make me look and keep reading a submission. Even if a designer hasn't been published before, love for it all— the spinning, the design—can go a long way.

Photographs don't have to be art-book quality, but make sure they convey what you as a designer want to convey about your piece. Make it sing.

A designer has to follow the submission guidelines. The few times I've let a pattern slide on this because I was charmed I've been sorry.

When you do get hired, don't mistreat the tech editor. No one writes a perfect pattern. The tech editor's job is to make your pattern better. They are not trying to hurt your feelings or say that your pattern is bad, they are trying to make it easier for people to knit it."

Editor of Interweave's *Knitscene* magazine, Amy Palmer

"Study your intended market. With so many knitting publishers out there, both large-scale and independent, a little bit of research will go a long way. Thanks to the internet in general and Ravelry in particular, prospective designers can see the kinds of projects a magazine typically publishes.

Presentation is important, but not so much a person's ability to draw or lay out something pretty on a computer—when I say 'presentation,' I'm looking for proof that you can turn this idea into a reality, especially if I've never worked with you before. A detailed description of how you plan to achieve the design, such as an 'order of operations' list or a paragraph describing how the project is constructed, is immensely helpful."

to be designed, including swatches, sketches, and a full overview of construction. List the sizes you intend to provide.

You're not just selling your design, you're selling yourself. Let them know a bit about you, too— provide a summary of who you are, your design experience, and information on previously published patterns. Be professional and detailed; taking the time to make your submission attractive is always worthwhile.

And make it clear that you have read their call for submissions. Publications often have a very specific vision, style, or other requirement, and these may vary from issue to issue (e.g., challenging colorwork designs for experienced knitters, innovative sock constructions, beginner-friendly lace, modern interpretations of classic designs, and so forth). Explain how your design fits a stated requirement.

Designer Karie Westermann has written a fantastic blog post about the proposal process, and shares a proposal she made for a recently published design.

"Tutorial: Creating a Magazine Submission"
http://www.fourth-edition.co.uk/?p=6105

Be thorough: submit everything the publication asks for. If they need sketches, do them. If they want a schematic, send that. If they want yarn recommendations, include them. In the words of yarn dyer Kim McBrien-Evans, who used to work for an organization that awarded grants to artists, if the submission guidelines ask for a ten-second video of you doing a handstand while singing the national anthem, do it. Many organizations reject submissions outright if they don't meet the basic requirements; a designer who fails to follow the rules is sending a bad message about their attention to detail.

It's also good form to be exclusive in your submission: don't submit a design to multiple publications at the same time. Wait for a rejection from the first before submitting the proposal to another. Most publications will have, in addition to a submission deadline, a response deadline and policy. For example, many publications inform all designers explicitly whether the design has been accepted or not. Some have a slightly different

approach: they will say that if you have not heard from them by a specific date, assume they're not using it. Obviously, one approach is more designer-friendly than the other, but make sure you're familiar with the policy so you know if and when you're free to submit your design to another publication.

The publication's call for submissions should provide information regarding how long you should expect to wait for a reply.

The Pattern

Pay close attention to the submission guidelines. A publisher will have specific requirements for the format of the pattern, the files to be submitted, and how to submit them. Most publications have a style sheet. Use it. If it asks for a .txt file with no formatting, that's what you send. If it asks for charts created in a specific application, do it. If it asks for gauge over four inches, that's what you provide. If it asks for a .doc file with the text in 12pt Georgia font, do it.

If there is a style sheet, USE IT.

If submitting a complete pattern, rather than a proposal or draft pattern, it's worth your time to match your pattern submission to the publication's format as much as possible. If the publication has a specific format for row numbering, use it. If they always provide three sizes for hats, have three sizes for your hat.

As I've said, for a pattern you'll be submitting for publication, a test knit is more useful than a technical edit. A test knit will help ensure that the pattern produces what you say it will, and allows you to be fully confident about the design you're submitting. A publication will always have your patterns tech-edited, and your pattern will be edited and reformatted to match their house style. Most publications give you a chance to review your pattern before it is finalized; make sure that you review it very, very carefully to ensure that it still works after editing.

ADVICE FROM THE EXPERTS:

Editor of *Knit Now* magazine, Kate Heppell

Kate Heppell wrote a fantastic blog post to prospective designers. It's worth reading the whole post, but here are a couple key quotes:

> "Think about presentation: Look on this like a (friendly!) job interview. Present yourself as you wish to be seen, particularly if we've not worked together before."

> "Read the call for submissions: This may sound obvious but somehow a lot of people miss this stage! A big part of becoming a designer is being able to deliver a design to strict specifications. You'll need to produce the pattern and submit the sample on time and in keeping with our requirements."

To read it in its entirety, visit the *Knit Now* website.

> Knit Now's Submission Tips for Designers: http://www.knitnowmag.co.uk/item/193-submission-tips-for-designers

Executive Editor of *Creative Knitting* magazine, Kara Gott Warner

"Read the guidelines and submission call. We've worked hard to establish themes and ideas, and they're there for a reason; pay attention to them.

We really love it when the designer has done her homework on the yarn. It's great when a designer finds a wonderful new yarn that we can introduce our readers to. And make sure it's a yarn that's readily available, that our readers are going to be able to find.

Our call for submissions asks for a swatch: Use that swatch to demonstrate what's special about your design, and what's different. Don't just send in a square stockinette stitch swatch; if there's a special raglan shaping, show us that. If there's a lace pattern stitch, show us that. If you've got a clever buttonband construction, show us that.

The best submissions are the ones that tell the bigger story about their design: not just explaining that it's a blue cabled sweater, but telling us the inspiration for the design, the emotions associated with it. Show us that your heart is really in the design."

Selling Online

In This Chapter

Once upon a time, all patterns were distributed through a handful of tightly controlled channels. They were printed in books and magazines or made available for purchase as physical leaflets, usually only in speciality shops. The Internet has changed everything. Designers can now sell their patterns worldwide, with no need to go through an official publisher. Now, the vast majority of patterns is distributed digitally, and distributing a pattern for free can be as simple as posting it on a blog.

If you want to sell patterns, there a couple of ways you can do it.

If you've got your own website, you can build the functionality into your own site. You'll need a way to accept payments—typically some kind of "shopping-cart" solution—and then a way to fulfill the orders—to deliver the pattern files. Many of the available shopping-chart solutions can also take care of delivery of the pattern files, but if you don't use one of those, you can simply email the files to purchasers (although this is only practical if your sales volume is low).

Most designers, however, use one of three popular websites that take care of all of it for you: Ravelry, Patternfish, and, though not as popular, Etsy. You don't even have to have your own website to take advantage of these platforms. All you need is patterns in a digital format (PDF is the accepted standard), a PayPal account, and an email address.

Ravelry

http://www.ravelry.com

Ravelry has massive reach in the knitting community—as of writing, there are over four million users, and the site continues to grow. It's commonly thought of as a social-networking site for knitters, but it's also immensely powerful as a marketplace. Designers can make patterns available—for free or for purchase—in their own Ravelry "store." The search functionality on the site is remarkably sophisticated, providing users very easy-to-use tools to identify precisely the pattern they're looking for, whether for a specific yarn, for a specific type of project, for a specific skill level, for a particular size, or for whatever they want.

In addition to making patterns available for purchase by Ravelry users, you can also choose to make your patterns available for sale through yarn shops, potentially extending your reach dramatically.

Lots of smart features make it easy to get started: Ravelry takes care of the transaction through PayPal, which offers decent security. Pattern updates can be sent to all purchasers/downloaders automatically. There is a small fee to Ravelry, in addition to whatever PayPal fees might be incurred. You can turn patterns on and off at will, you can create sales and promotions, and Ravelry's reporting is detailed.

Ravelry's native commenting and messaging features are a boon to both designers and knitters: a knitter with a question can easily get in touch with the designer. The knitter gets the help needed to work the pattern, and the designer turns what could have been a negative experience into a positive one. And knitter feedback and questions can help improve patterns: if you keep getting the same question about a pattern, chances are it's a sign that there's a mistake, or there's an instruction that needs some clarification.

It's worth noting that many knitters feel that finding a pattern on Ravelry is some sort of mark of quality, but this simply isn't true. Of the literally tens of thousands of patterns available on Ravelry, there are many that are of a professional quality, but the majority of them simply aren't. Comments are a useful guide, for both the knitter who is shopping for a pattern and for the designer to learn more about knitters' impressions of a pattern.

You can post any sort of pattern on Ravelry— whether a professionally photographed and laid out, fully tech-edited write-up, or just a few notes providing a generic "recipe," or something in between. The key is to be clear which your pattern is.

The documentation for getting set up and uploading patterns on Ravelry is terrific, and the process is entirely clear. When uploading a pattern to make available for sale or for free download, you must enter key information about the pattern. The better the information you enter, the more

ADVICE FROM AN EXPERT: Designer & Yarn Shop Manager Lynne Sosnowski

I spoke with designer and yarn shop manager Lynne Sosnowski about how to best take advantage of Ravelry, to be noticed by knitters and yarn shop employees.

Lynne recommends you take your time choosing the tags for the pattern—these are identifiers you can select to aid searching: "Select all that apply. It's worth playing with the search functionality to see how these tags are used. The more tags you choose, the more ways your pattern can be found."

In fact, Lynne gave such a comprehensive overview of things to know as a designer selling on Ravelry, that she kindly let me edit and repurpose it into the following three sections on how best to list your pattern, making your pattern stand out, and monitoring your pattern after release.

easily the pattern will be found by knitters, and the more likely they will be to buy it. This pattern information is how you sell your work.

In addition, advertising is available on Ravelry, and many designers create discussion groups to support their patterns and engage their users.

For more information, sign up for a free Ravelry account and read the Quick Start Guide in their wiki.

Pattern Seller Quick Start Guide
http://www.ravelry.com/wiki/pages/
DesignerQuickStartGuide

Ravelry's Pattern Notes Section

This is the place where you can most help a knitter and convert someone from thinking "that looks interesting" to "buy now."

- Describe the item to be made: This is where you can put your "beauty" message, talk about your inspiration behind the design, and address your intent.

- List any unique features or design elements: Why should someone choose this pattern over another?

- Does your pattern address a need or a mood? For example, "This pattern will be of interest to someone looking for a quick gift," or, "This pattern looks complicated but relies upon easy stitching in colorful yarn," or perhaps, "This item is worked in sections and is reasonably portable."

- Break out detailed size options and yarn requirements. Give it for each size, in number of skeins of the specified yarn as well as total yardage per size.

- Talk about intended fit and ease, what options exist for modifying fit, etc.

- If more than one kind or type of yarn is needed, spell each out separately, in detail.

- If some elements are optional, list them and explain why.

- Identify any changes in needle sizes, needles used, or special equipment required.

- State any changes in gauge or alternate patterns used and their gauge; state clearly what gauge and pattern stitch to swatch in; and whether the swatch should be blocked or not.

- Discuss yarn substitutions and spell out desired yarn characteristics. For example, "This pattern works up best in a soft yarn with some drape, such as a wool/alpaca blend," or, "In order for the bobbles to be visible, this pattern works best in a tightly twisted wool yarn with balanced plies," or, "A kettle-dyed or tonal yarn will show the stitches to best advantage."

- Alert the knitter to any specialized techniques needed. Discuss if tutorials are available, and if the instructions are in written or charted form or both. (The tags you selected earlier help patterns be found in searches, but some users don't read them and it's best to repeat that here.)

ADVICE FROM AN EXPERT: Designer Woolly Wormhead

Hat knitter extraordinaire Woolly Wormhead offers her full catalog of patterns through Ravelry, and I spoke with her about it.

Why do you use Ravelry to sell patterns and what advantages do you see in it?

Ravelry make selling patterns pretty straightforward. The team have built (and continue to develop) a system geared towards their customers and users; they put the indies and small businesses first. The ability to use the shopping cart on your own website is invaluable, and the library function means you can keep your customers updated with errata, new versions, and so forth.

Advantages? The community! You have the chance to engage directly with your customers and knitters— your audience—and that's something that can never be underestimated. It's a focused market, right there. Knitters can see projects by other knitters, they can share their modifications and yarn choices and thoughts on a pattern, and word of mouth is the very best way to get your designs out there.

Any tips to share for presenting the best possible image, for taking advantage of the features Ravelry offers, how to maximize sales?

Photography is so important—it doesn't have to be pro, and it doesn't need to be arty, but it does need to be clear and well presented, preferably taken in natural light. And the more angles the better. In fact, I'd say the same for the pattern details, too—the more sizes, the more yarn choices, the more details you can share about your pattern up front, the better. Knitters are spoilt for choice on Ravelry, and you'll want to make sure your pattern is remembered (and purchased and, preferably, knit). Reputation is key, too. Presenting patterns well is one thing; making sure they're clear and well written is another, and at the end of the day, it doesn't matter how shiny your images are if the instructions aren't up to scratch. Get them tested and edited.

- If the pattern is part of a collection, talk about the features of the collection and what the collection contains, and provide links to other patterns in the collection.

- If you're using a promotion or discount code, explain the terms and how to use it.

- Wrap up with a statement of thanks. For example, "I love thinking up new ways to make and decorate mittens. Thank you for your interest in my work."

This section ends up being a combination of your pattern-introduction and pattern-note sections. If the pattern is a free download, less information is required, as the user can learn more from the pattern itself. If the pattern is being sold, then this is your only opportunity to communicate what your pattern is all about, and to convince a knitter to purchase it.

When uploading photos to Ravelry, carefully consider the order they appear in. THE FIRST PHOTO IS CRITICAL—this will be the "face" of your pattern all over Ravelry. Note that you can upload photos in any order and then rearrange them to put the one you think is best as the first.

Making Your Pattern Stand Out on Ravelry

Making your pattern stand out from the hundreds of thousands of others on Ravelry will take some effort on your part and will rely on no small amount of luck.

First, make sure that your own version of the pattern is entered as a project, along with those that your test knitter(s) completed. The more times your pattern has been knit, the more a buyer has the opportunity to see it made in different yarn choices, sizes, or colors; and the more confidence they gain that the instructions can be understood by a wide range of knitters.

If you can think of a topic, there is probably a Ravelry group (discussion board) for that topic. Groups are a good way to promote your patterns, but some groups have rules against outright promotion, and others have guidelines about where and how they welcome that sort of information. Start with groups you already belong to and where you might be known—perhaps a group based in your city or community? Search for groups that might share your interest—Victorian

groups for a steampunk hat, or parenting groups for kid's mittens. It's good manners to join whatever groups you are posting in, and even better manners to abide by their posting guidelines. Ask a moderator of the group if you are unclear of the rules before posting. Note that cross-posting the same content from group to group is considered "spamming" and is against Ravelry's Terms of Service. Modify your content to suit the needs and rules of each group in which you post.

You can also purchase advertising from Ravelry. There is a dizzying array of options, most of which are very affordably priced even for emerging designers.

Let your friends know you've released a new pattern. Having people click "favorite" on a pattern or add it to their queue increases the pattern's ratings and makes it more likely to turn up in searches. When someone favorites or queues your pattern, it shows up to their friends in their "friends' activity" tab, and then their friends can see it as well. Lots of Ravelry users browse through their friends' activity to see what's new and what their friends—real life and virtual—are interested in knitting.

Monitor Your Ravelry Patterns

Once your pattern is uploaded and released, it's a good habit to check in periodically to see what people are saying about your work.

On the pattern detail page, members of Ravelry can make comments. You should also receive a copy of each comment in your Ravelry message center—make sure you haven't turned this feature off on the pattern comment page. You have the ability to respond to each comment directly to the commenter (saying "thanks" when they offer a compliment, for example) and can choose to have a copy of your response appear on the comment page (clarifying a detail or instruction that might be of interest to more than the person asking).

Be careful not to give too much away on the comments page—you don't want to reproduce lines of instructions when someone has a question. But do respond publicly to each question with something along the lines of, "I see you have some questions about how the neckties get attached."

Patternfish

http://www.patternfish.com
Patternfish is a little different from Ravelry. It is a site strictly for knitters to browse and buy knitting and crochet patterns. There are no free patterns, and no additional content such as discussion groups and personal project pages.

There is also a degree of control exerted on what is listed—a designer must apply to list their patterns. Patternfish supports both corporate and independent designers. They don't care what the patterns are for, but they look for a certain degree of quality in the patterns. They also have a lower limit on prices: Nothing is sold for less than $4.

 ADVICE FROM AN EXPERT: Founder & Prime Minister of Patternfish, Julia Grunau

People will absolutely pay for patterns that are written to a high standard. Not only that, but they'll come back to pay again and again once they trust you.

Our customers come to think about designers the same way they might feel about chefs and cookbook authors. If you make something of Jamie Oliver's, say, and his recipe is clear and comprehensible and easy to follow no matter

how complicated the dish, you're much more likely to go back to the same source for your next meal. Same thing with patterns.

Circumstances may force people to economize on yarn, but our customers know that economizing on the blueprint for twenty or more hours of their time is just plain stupid.

The fees are higher on Patternfish than on Ravelry, but they do active marketing. There is a monthly newsletter with a significant subscriber list, and they buy ads in online and print magazines to promote their marketplace.

Setting up patterns for sale on Patternfish is entirely straightforward, and they've got lots of tags and ways to identify your pattern for it to be found with their search tools. And if you release a new version of the pattern, it's a quick upload of the new file.

Patternfish is very focused on protecting designers' intellectual property, and on helping to educate users about the use of copyrighted patterns. They add some protection and identification to the patterns downloaded: PDFs are coded so that they are locked and no changes are permitted, and user name and download information is added to a footer on the pattern.

To learn more, visit the Patternfish website.

About Selling on Patternfish
https://www.patternfish.com/about_selling

BECOMING A BETTER PATTERN WRITER: Stalk Your Patterns

A useful feature on Ravelry and Patternfish is that knitters can leave comments on your patterns. You should absolutely use this to your advantage and see what they are saying.

If the same question keeps coming up, consider whether there's a mistake in the pattern, or an instruction that needs clarification. If you're asked for pointers to a tutorial on the cast-on, add that to the pattern glossary. If you're being asked about what a particular instruction means, revise it. If you're being asked about finding yarn substitutions, add some extra detail.

And don't just look at the comments, look at the projects and what notes knitters have made about them. Many times, they might not address you directly on something, but their raves and grumbles can provide excellent insight into how knitters feel about your pattern and the knitting experience.

ADVICE FROM AN EXPERT: Designer Deb Gemmel

Patternfish is a site dedicated to designers. It provides a platform for sales so that you, the designer, can spend your time designing. They are always responsive to inquiries and suggestions.

One of the great advantages of Patternfish is that when knitters arrive at the site they know they are paying for a pattern. All of the designers have done the work needed to provide a portfolio of patterns that the knitter will be happy to knit. The site also provides access to the designer, where knitters can ask questions and get more information. I think access is very important and gives the knitter more confidence in their purchases. Receiving feedback and questions from knitters is always helpful. Criticism and questions are a great help to the designer striving to develop better written patterns. They help you understand who is buying your pattern and what their experience and expectations are. I think that well-written patterns are one of the reasons a knitter will come back and purchase more of your patterns.

Etsy

http://www.etsy.com
Though Etsy.com positions itself more as a
marketplace for finished items, some designers do
choose to sell digital patterns there.

The fees are higher than on Ravelry, and because
it's not a dedicated knitting site, the audience is
more diluted. I spoke to a couple of designers who
sell patterns on Etsy.

Emily Ringelman says that she's been listing
patterns for sale on Etsy since 2009, but it's not one
of her primary channels. She praises the site's
ease of use: "...pretty much all you need to start an
Etsy shop is a shop name, a banner/shop photo,
and something to list. It's pretty easy and decently
self-explanatory," but reports that the knitters
buying her patterns through Etsy tend to be less
experienced than those buying them through
other sites.

Nadia Majid sells predominantly knitting tools
and accessories, but she has also listed a small
number of patterns. She agrees with Emily that
Etsy is very easy to use for the seller, and mentions
that it offers more payment options than other
sites, which can be helpful for buyers. But she also
agrees that patterns aren't a big seller, and the
general audience skill level seems to be lower than
that of knitters purchasing through other sites.

For more information, visit the Etsy help page
and look at the topics under the Getting Started
heading.

How Can We Help You
https://www.etsy.com/help/

On Copyright

In This Chapter

Copyright is a broad and complex topic. Even though many countries adhere to a number of international treaties dealing with copyright and other intellectual property rights—meaning that creators enjoy similar protections nearly worldwide—copyright laws still vary between jurisdictions and remain in flux as individual countries tweak their laws to catch up with changing attitudes and technologies.

I am not a lawyer, and although this section was thoroughly vetted by a copyright lawyer, these comments do not constitute legal advice and aren't intended to act as or replace legal advice. I only wish to provide you with a general introduction to copyright and to flag some issues for your own research and consideration. For more information, or for advice, consult a copyright lawyer.

What Is Copyright?

Copyright is only one form of intellectual property protection: the protection of the expression of your intellectual labor.

At its heart, copyright is about the right to make copies. However, it doesn't exist solely to protect you, the creator. Rather, copyright law seeks to strike a balance between your right to control the extent to which others can copy your works, and the rights of users to make use of and benefit from what you've created.

Copyright can be described as a set of exclusive rights that you can sell or license in whole or in part, or waive altogether, and a set of permissions given to the public that you cannot take away, except by contract (such as a license agreement). These rights and permissions arise automatically when a work is created, and as a general rule, last for decades (fifty or more years after the author's death, in many countries). The copyright owner has the exclusive right to reproduce or distribute a copyrighted work, or to authorize a reproduction (which does not need to be exact, but must be a substantial copy in quantitative and/or qualitative terms), whether in print, electronically, or otherwise. Anyone who does, without permission, what only the copyright owner may do is infringing copyright. Remedies for copyright infringement include injunctions and payment of damages.

The public, on the other hand, has the right to make a "fair use" of the copyrighted work for certain purposes. What is "fair" depends on the nature of the use—whether it is for profit, how much is used, and the impact of the use on the value of the copyrighted work. Note that there are slight differences between the U.S. "fair use" provisions and the Canadian "fair dealing."

What Is Copyrightable?

National copyright laws list specific categories of works that are protected by copyright. These categories generally include literary, artistic, photographic, audible, and videographic works. Some countries extend copyright to protect works of artistic craftsmanship, which can include handmade objects such as sweaters and socks; others do not. The scope of these categories, however, is a question of legal interpretation. Mere ideas or concepts are not protectable by copyright.

So, the concept of a sweater, sock, or scarf is not copyrightable, nor is a clever new construction method. A stitch pattern, or the design of a knitted item—the combination of shape and construction and fabric and yarn choice and the math and all the details—may or may not be copyrightable, depending on each country's laws.

Your instructions for making that stitch pattern or design, however, are copyrightable. And the photographs? Absolutely.

A technique is not copyrightable, but your written or pictorial explanation of the technique or a video demonstration is.

It goes without saying that your work must be original to you.

What's Yours? What's Original?

Copyright law provides protection only for "original" works: A work must be original to you if you are to enjoy copyright protection.

What makes a work "original" is a legal issue, but note that there's an important difference between "original," and "unique" or "new." What "original" means, broadly speaking, is that there must be some of your own intellectual input in the work—it must not be based wholly on external sources. It doesn't mean that you must have been the first to produce the work or anything like it. Chances are, your design isn't unique—there are lots of patterns for cabled socks out there, and there may even be one that uses the same cable elements you did. But this does not preclude your instructions or design from being original and copyrightable.

Consider a stitch pattern such as Feather and Fan. There are probably thousands of scarf and rectangular stole patterns that use Feather and Fan. Each can be distinct and copyrightable; what the designer owns is the execution and the instructions. The Feather and Fan stitch on its own isn't copyrightable or owned by anyone (or at least, not anymore), but what you do with it can be.

The original owner of copyright is, by default, the creator of the work. However, there are exceptions to this rule. If you're publishing your work with an external publisher—in a book, a magazine (online, digital, or physical), check the terms of your contract on copyright and ownership. Some publishers retain copyright and ownership for themselves (sometimes for a limited period, sometimes forever); others let the designer keep copyright.

How Do You Copyright Your Work?

Your work is automatically protected by copyright once it exists in some kind of fixed form. Simply talking about an idea to someone does not count as a "fixed form," but a text message, email, written document (either by hand or on a computer), and an audio or video recording does. When you make your work available to others, though, you should still include a copyright notice that includes the universal copyright symbol, the year of first publication, and the copyright owner's name:

© Kate Atherley, 2015

Or if your font isn't clever enough to include the symbol, spell it out:

Copyright Kate Atherley, 2015

You will see that some copyright notices include additional statements, such as "All rights reserved." Statements such as these can be used to signal to the user that you are not implicitly ceding any of your rights. However, if you want to impose additional restrictions on what users can do with your work, above and beyond what copyright protects, you may need to have users agree to a contract, such as a license agreement, first. Think of software licenses or website terms of service that you have to agree to before you can install an app or use a website's services. Generally, you cannot unilaterally impose limitations on the public's rights in a mere copyright notice.

What Is Creative Commons Licensing?

The Creative Commons license is a way to approach copyright in a manner that is more favorable to users than default copyright rules are. One of its key objectives is to assuage concerns about copyright infringement by spelling out (as clearly as can be done in legal terms) what users are permitted to do, and providing users with a minimum set of permissions that go beyond what basic copyright law gives them. The Creative Commons license provides an easy tool for copyright holders to specify whether they permit users to adapt and/or use their works commercially, based on predefined sets of legal terms.

For example, a designer who publishes a chart for a cable-stitch pattern could explicitly permit others to use that stitch pattern and chart in their

own designs and patterns. Or a designer may wish to give explicit permission for knitters to create variations of their work, or to make and sell finished items from the pattern.

However, Creative Commons is not a solution for all licensing needs. All versions of the Creative Commons license give the user permission to reproduce and share your work (with credit given back to you). If you want to control who's distributing your work, Creative Commons is not for you. The Creative Commons license is also irrevocable—you can't take it back and expect a user who already obtained a copy of your work under a Creative Commons license to be bound by different terms.

If you are interested in setting specific terms about the sale of items made from your pattern, or are concerned about distribution, you should consider a different approach, such as creating a specific licensed version. But if you are content to have your work shared by others and are only concerned that your name remain attached, a Creative Commons license may be a friendly way to let others know.

You can read more about Creative Commons on their website and on Wikipedia.

> **About Creative Commons**
> http://creativecommons.org/about
>
> **Creative Commons License**
> http://en.wikipedia.org/wiki/Creative_Commons_license

Must Copyright Be Registered?

Some countries permit you to register your copyright with a government agency. Copyright registration is not mandatory, and many people do not register to avoid the fees involved, but you should do this if you feel that legal action may be required to enforce your rights. In the U.S., register copyright through The Library of Congress; in Canada, register through the Canadian Intellectual Property Office.

Library of Congress
United States Copyright Office
eCO Registration
http://copyright.gov/eco/

Canadian Intellectual Property Office
Copyright E-Filing
http://bit.ly/1FGMOlB

What Can You Do with Other People's Copyrighted Work?

It is inevitable that some of what you create is a reproduction, in some form or part, of what has come before—we all build on knowledge we've acquired from others. If what you take from other people is not protected by copyright, then copyright will not prevent you from incorporating it into your own work and exploiting it; but if what you take is protected by copyright, your ability to do so is governed by the same rules that govern what others can do with your work.

Stitch Libraries

Can a knitter use a pattern stitch from a pattern library in a larger design for publication?

Maybe. Best practice is to seek permission of the copyright owner of the pattern-library publication, and give credit to the source.

Reverse Engineering

Can you publish instructions you created to reproduce a garment you saw elsewhere?

Maybe. It depends in part on what you're reproducing and its copyright status—is it only the style lines and the fit, or is it specific graphic elements (such as an intarsia design)? You should note that there are some iconic designs that may be protected by some form of intellectual-property right that might impact your freedom to do this.

Derivative Works

What if a knitter's thing is just a "riff" on an existing thing?

Assuming the parts of the thing that you take are protected by copyright, it depends on how much, quantitatively and qualitatively, you're taking.

There's no magic number as to how many things you have to change, or how different it needs to be. When I was first designing, I was told that as long as I changed five things I could consider my design to be my own work. Just not true. How significant do those changes need to be? If I change the color of the yarn, the needle size used, the length of the scarf, the number of stitches in the garter-stitch edging, and the name of the pattern, it's still the same scarf it was when someone else designed it. The same goes for the "30 percent difference" myth that makes the rounds—it's just not true.

You will find that in libraries, a "10 percent rule" is sometimes followed for photocopying. This is a rule of convenience followed by libraries and copyright collectives (who represent publishers) to gauge when too much is being copied from a single work; it is not a rule that applies to all types of works, across the board.

In any event, 10 percent or another percentage is easy to calculate when you're counting photocopied pages; it's not an easy thing to calculate when you are talking about other forms of creative work.

Also consider your artistic and design integrity—how much is there in making a mere modification to someone else's design?

Educational Use

Can a knitter teach a class using someone else's pattern?

While it may not be legally necessary, it's very good form to contact the designer to ask for permission to teach a class on that pattern, and sometimes it's a good idea because the designer may be able to provide you with additional tips and resources. However, you do need to buy (or have the students buy) copies of the pattern for use during class.

Borrowing from Friends

Can a knitter borrow a book or pattern from a friend and make a copy of it for his or her own use?

Probably, if it's just the lone knitter using that pattern for her own private use, and she's not distributing that copy any further, and the physical owner of the book isn't making the same thing at the same time or engaging in a habit of lending it out to multiple people.

Libraries and Copyright

Can a knitter borrow a book or a pattern from a library and make a copy of it for his or her own use?

Institutional and public libraries, for the most part, pay license fees to copyright collectives who represent book publishers; the fees are estimated based on the amount of copying expected to be done using the library's resources. This ensures that at least some compensation finds its way back to copyright owners.

Managing Your Copyright

If you think someone is infringing on your copyright, tread firmly but carefully. Document the situation as much as you can. If it's a website, take screenshots. Save emails. Take photographs of scanned patterns.

Refrain from making public accusations—what if you're wrong?

Notify the person privately (either yourself or through a lawyer, if you choose) that you believe they are infringing your copyright.

If you are reasonably certain of your understanding of the law, you may choose to educate the person as to what is and isn't permissible. Pointing them to an external information source is helpful. It's entirely possible that they aren't aware that what they are doing isn't appropriate and/or permitted.

And of course, speak to a legal professional who specializes in copyright law.

Other Types of Intellectual Property Protection

Copyright is only one form of legal protection for works of intellect. There are other forms of intellectual-property protection that cover different types of subject matter.

Patents protect machines, methods, and physical items—many of the things that copyright doesn't protect. A patent grants a time-limited monopoly on making, using, or selling the protected invention, and is the most difficult (and expensive) type of protection to obtain and enforce. Patents do not protect merely aesthetic or informational items (which are more likely to be copyrightable, instead).

Design patents or industrial designs protect novel ornamental features applied to useful objects, which can include the aesthetic features of a knitted garment. The subject matter of a design can sometimes overlap copyrightable subject matter. Design protection is often easier to obtain than patents, but is still more expensive to obtain than copyright.

Trademarks are names, symbols, sounds, colors, and other perceptible signs that designate a particular source of a product or service.

Where to Get More Information

Vogue Knitting has an article on their website, but be aware that it only addresses U.S. law:

"Ask a Lawyer! Knitting and Copyright"
http://www.vogueknitting.com/magazine/article_archive/ask_a_lawyer_knitting_and_copyright.aspx

There is a group on Ravelry that covers this topic. Be warned: although some content in this group is helpful, a lot simply isn't. There are a lot of amateurs expressing opinions, and even those who have some legal knowledge and training aren't necessarily able to speak to a specific situation, or a specific country's/region's laws.

Copyright Matters Ravelry Group
http://www.ravelry.com/groups/copyright-matters

Your local government can be a great resource, too. U.S. designers should visit the U.S. Copyright Office's website for more information and the full text of the law.

Library of Congress
United States Copyright Office
http://copyright.gov/

Copyright Law of the United States
http://www.copyright.gov/title17/

Canadian designers should visit the Canadian Intellectual Property Office's website for more information and the full text of the law.

Canadian Intellectual Property Office
Copyright
http://bit.ly/1B36SRc

Canada Copyright Act
http://laws-lois.justice.gc.ca/eng/acts/C-42/Index.html

In Canada, Canadian Artists Representation/Le Front des Artistes Canadiens (CARFAC) follows and advocates for artist/designer copyrights in Canada. The Ontario branch, based in Toronto, provides a legal consultation process for this. Members can access a one-hour legal consultation.

CARFAC
http://www.carfac.ca/

Appendix A:
Basic Pattern Template

Each section that follows is required in a pattern. For more details on any section, consult the relevant chapter in the book.

Pattern Name

Distinct! Memorable!

Introduction

Inspiration.
Overview of design.
Summary of construction.
Comments on yarn used.

Difficulty Level or Skills Required or Techniques Used

Include one of the following:

Difficulty Level

Beginner/Advanced Beginner/Intermediate/
Experienced

Easy/Intermediate/Challenging

Skills Required/Techniques Used

Examples are below. Include whichever are relevant, and add whatever else you need.

Knit & purl, cast-on & bind-off

Increasing, decreasing

Specialty CO: list

Specialty BO: list

Working in the round on circular needles

Working small circumferences in the round on DPNs/with magic loop/with two circulars

Working from charts

Short-rows

Cables

Lace

Stranded colorwork

Intarsia

Experience with toe -up/top-down sock knitting

Picking up stitches

Seaming

Kitchener stitch/grafting

Advanced finishing skills: list (e.g., steeking)

Basic crochet stitches

Materials

Yarn
SINGLE YARN/COLOR

CompanyName YarnName (fiber content; #yds/#m per #oz/#g skein/ball); # skeins/balls

Sample uses color #/name

MULTIPLE COLORS

CompanyName YarnName (fiber content; #yds/#m per #oz/#g skein/ball)

MC color #/name; # skeins/balls

CC1 color #/name; # skeins/balls

CC2 color #/name; # skeins/balls

Needles

FOR ITEMS WORKED FLAT:

mm/U.S. # needles

OR

mm/U.S. # needles for working flat

OR

mm/U.S. # needles for working flat—
straight or short circular as you prefer

FOR ITEMS WORKED IN THE ROUND ON A CIRCULAR NEEDLE:

mm/U.S. # #-inch/#cm circular needle

FOR SMALL-CIRCUMFERENCE ITEMS WORKED IN THE ROUND:

mm/U.S. # DPNs

OR

mm/U.S. # 32–40 inch (81.5–101.5 centimeter) circular for magic loop method

OR

Two # mm/U.S. # 16–24 inch (40.5–61 centimeter) circulars for two-circulars method

OR

mm/U.S. # needles for working small circumference in the round: DPNs, 1 long circular or 2 short circulars

METRIC SIZE/U.S. SIZE CONVERSIONS

1.5 mm/U.S. #000

1.75 mm/U.S. #00

2 mm/U.S. #0

2.25 mm/U.S. #1

2.5 mm: No standard equivalent; some patterns list as 1.5

2.75 mm/U.S. #2

3 mm: No standard equivalent; some patterns list as 2.5

3.25 mm/U.S. #3

3.5 mm/U.S. #4

3.75 mm/U.S. #5

4 mm/U.S. #6

4.5 mm/U.S. #7

5 mm/U.S. #8

5.5 mm/U.S. #9

6 mm/U.S. #10

6.5 mm/U.S. #10.5

7 mm: No standard equivalent; some patterns list as 10¾

7.5 mm: No standard equivalent

8 mm/U.S. #11

9 mm/U.S. #13

10 mm/U.S. #15

12 mm/U.S. #17 (sometimes)

12.75 mm/U.S. #17 (sometimes)

15 mm/U.S. #19

19 mm/U.S. #35

20 mm/U.S. #36

25 mm/U.S. #50

Notions

Examples are below. Include whichever are relevant, and add whatever else you need.

Cable needle(s)

Stitch markers

Stitch markers—removable; 1 of different color or style for marking start of round

Stitch holders

Length of contrasting color waste yarn for stitch holder/provisional CO

#mm/U.S.# crochet hook

Pom-pom maker

Yarn needle

#-inch/#cm buttons

sewing needle and thread for attaching buttons

#-inch/#cm zipper

elastic - #-inch/#cm width, #-inch/#cm length

Gauge

If worked flat:

sts/# rows = 4 inches (10 centimeters) square in stockinette stitch using #mm/U.S. # needles

sts/# rows = 4 inches (10 centimeters) square in pattern stitch using #mm/U.S. # needles

If worked in the round:

sts/# rounds = 4 inches (10 centimeters) square in stockinette stitch using #mm/U.S. # needles

sts/# rounds = 4 inches (10 centimeters) square in pattern stitch using #mm/U.S. # needles

Size Information

Sizes
List all sizes, by name.

First (second, third, ...)

XS (S, M, L....)

Finished Measurements
Give key dimensions for all sizes.

Dimension 1: # (#, ...)

Dimension 2: # (#, ...)

Guidance on choosing a size, e.g.:

Choose a size based on...

Choose the size closest to your actual measurements...

Schematic
Include one for anything but very basic shapes.

Abbreviations, Glossary, References, Techniques

Specialty CO Instructions/Reference

Specialty BO Instructions/Reference

Special stitches instructions: decreases, increases, cables, etc.

References.

Pattern Notes

Construction overview

Tips for working the pattern

Tips for adjusting size

Alternate versions

Pattern Stitch Written Instructions

Pattern Stitch Charts

Chart Legend

Method

See Specific Pattern Templates.

Name of Piece/Section

For pieces worked flat:

Using size x needles and y yarn, using Long Tail/cable/backward-loop method CO...

For pieces worked in the round on a circular:

Using size x circular needle and y yarn, using Long Tail/cable/backward-loop method CO Place marker and join for working in the round, being careful not to twist.

For small circumference pieces worked in the round:

Using size x needles and y yarn, using Long Tail/cable/backward-loop method CO Distribute across needles as you prefer and join for working in the round, being careful not to twist. Note or mark start of round.

Key Phrases

Using scrap yarn and provisional method, CO …. Join working yarn ….

Work even until piece measures … ending with a WS row.

Continue in pattern as set …

Ending with a WS row.

Ending with a RS row.

Bind off loosely.

Bind off in pattern.

Bind off, using larger needle to work stitches.

Bind off, using … method.

With RS facing, rejoin yarn and pick up and knit…

Finishing

Block.

Seams; edgings.

Weave in ends.

Designer and Pattern Information

Contact Information

Designer name

Website; Ravelry store URL

Email address

Brief biography

Credits

Photographer

Tech editor

Test knitter

Graphic designer/layout

Copyright Statement

(c) Designer name, year

Date, Version Number

Version #, month/year

Appendix B:
Abbreviations, Standard Terms & Glossary

I can guarantee that the following isn't complete, but it is a reasonably comprehensive list of common abbreviations and their definitions.

– A –

alt: alternate

approx.: approximately

– B –

beg: begin(ning)

bet: between

BO: bind off

BOR: beginning of round/row

– C –

CC: contrasting color

CDD: centered double decrease (usually S2KPO, but sometimes SK2PO)

ch: chain (crochet)

circ: circular (needle)

cm: centimeter

cn: cable needle

CO: cast on

cont: continue/continuing

– D –

dec: decrease/decreasing

DPN(s): double pointed needle(s)

– E –

EOR: end of round/row

est: established

– F –

foll: follow/follows/following

– G –

g or gm: grams

– I –

I-cord: Using either two double-pointed needles or a short circular needle, CO the number of sts directed. Knit these stitches. Instead of turning work around to work back on the WS, slide all sts to other end of needle, switch needle back to your left hand, bring yarn around back of work, and start knitting the sts again. I-cord is worked with the RS facing at all times. Repeat this row to form i-cord. After a few rows, work will begin to form a tube.

in(s): inch(es)

inc: increase/increasing

incl: including

inst: instructions

–K–

k: knit

k tbl: knit through back of loop

k2tog: knit 2 sts together (1 st decreased)

k2tog tbl: knit 2 sts together through back of loop (1 st decreased)

k3tog, k4tog…: knit the specified number of sts together

kfb: knit into front and back of stitch (1 st increased)

kwise, knitwise: as if to knit (usually accompanies a slip instruction)

– L –

LH: left hand (as in left-hand needle)

LLI: Left Lifted Increase: With left needle, lift the st two below the st just worked, and knit it. (1 st increased.)

– M –

m: marker

m: meter(s)

M1: Make one st: Insert left needle, from front to back, under strand of yarn that runs between last st on left needle and first st on right needle; knit this st through back loop. (1 st increased.)

M1: Make one stitch, backward-loop method: Make a backward (e-wrap) loop and place it on the right needle. (1 stitch increased.)

M1L: Make one left: Insert left needle, from front to back, under strand of yarn that runs between next st on left needle and last st on right needle; knit this st through back loop. (1 st increased.)

M1P: Make one purlwise. Technique varies—always define. Typically, this is just the M1R but with the lifted loop purled rather than knit.

M1PL, M1PR: Worked as for M1L and M1R, but the loops are purled rather than knit.

M1R: Make one right: Insert left needle, from back to front, under strand of yarn that runs between next st on left needle and last st on right needle; knit this st through front loop. (1 stitch increased.)

MB: make bobble. (Note: There are many different ways to do this, detailed instructions should always be provided.)

MC: main color

meas: measure(s)

mm: millimeter(s)

mult: multiple

– O –

opp: opposite

oz: ounces

– P –

p: purl

p2tog: purl two sts together (1 st decreased)

p3tog, p4tog...: purl the specified number of sts together

patt(s): pattern(s)

pfb: purl into front and back of st (1 st increased.)

pm: place marker

psso: pass slipped stitch(es) over

p tbl: purl through the back loop

pwise, purlwise: as if to purl (usually accompanies a slip instruction)

– R –

rem: remains/remaining

rep: repeat

rev St st: reverse stockinette stitch

RH: right hand (as in right-hand needle)

RLI: Right Lifted Increase: With right needle, lift the right leg of st below the next st, and knit into it. (1 st increased.)

RS: right side(s)

rnd(s): round(s)

– S –

sc: single crochet

S2KPO: slip 2 sts together as if to knit, knit 1 st, pass 2 slipped sts over. (2 sts decreased.)

SKP: slip 1 st as if to knit, knit 1 st, pass slipped st over. (1 st decreased.)

SK2P: slip 1 st, k2tog, pass slipped st over. (2 sts decreased.)

sl: slip (generally purlwise, unless otherwise indicated)

sl st: slip stitch

sm: slip marker

SSK: slip the next 2 sts, one by one, knitwise; insert the tip of the left needle, from left to right, into the fronts of those 2 sts and knit them together. (1 st decreased.) (Note: variations exist. See SSK on pages 30–31.)

SSSK: slip the next 3 sts, one by one, knitwise; insert the tip of the left needle, from left to right, into the fronts of those 3 sts and knit them together. (2 sts decreased.)

SSP: slip 2 sts as if to knit; return these sts back to the left needle, then purl them together through the back loop. (1 st decreased.)

st(s): stitch(es)

St st: stockinette stitch (This is the U.S. term; stocking stitch is the term more commonly used in the U.K. and Canada.)

– T –

tbl: through back of loop(s)

tog: together

– W –

WS: wrong side(s)

w&t: Wrap & Turn. There are variations, so always define which one. The simplest definition is: Slip next st to the right needle, take yarn to opposite side of work between needles, slip same st back onto left needle. Turn work, ready to begin working in opposite direction. If you expect the knitter to work the wrapped stitches together with their wraps, indicate that, and provide instructions, as there are variations for this, too.

Working wrapped stitches together with their wraps, on the knit side: There are variations, always define. Insert tip of right needle into wrap from underneath, insert tip of right needle into the st as normal, and knit the st and its wrap together.

Working wrapped stitches together with their wraps, on the purl side: Use tip of right needle to pick up wrap from the other side of the work, from underneath, pulling the wrap up onto the left needle, and purl the st and its wrap together.

wyif: with yarn in front

wyib: with yarn in back

– Y –

yd(s): yard(s)

yfwd: yarn forward; U.K. term for YO (typically used specifically for a YO worked between knit sts). See yo, yon, yrn.

yo: yarnover: create a hole by wrapping the strand that runs between the st just worked and the next st over the needle. Generally defined as "bring the yarn to the front, between the needles," but this only works if you're working this between 2 knit sts. See yfwd, yon, yrn.

yon: yarnover needle; U.K. term for YO (specifically for a YO worked between and purl and a knit; wrap the yarn over the needle, from the front over to the back. This can be confused with yrn.) See yfwd, yo, yrn.

yrn: yarn round needle; U.K. term for YO (specifically for a YO worked between knit and purl sts, or between two purl sts; bring the yarn to the front, between the needles, as if to purl [or if you've just purled, it's already there], then wrap the yarn over the needle again). See yfwd, yo, yon.

Appendix C:
Resources & Bibliography

Sample Publisher Style Sheets & Submission Guidelines

Always consult the website or masthead of a publication to ensure you have the most up-to-date style sheet and guidelines, but even previous versions of a style sheet can provide a lot of value as inspiration for developing your own.

Creative Knitting **Magazine**
http://www.creativeknittingmagazine.com/designer_guidelines.php

Interweave Knits **Magazine**
http://www.knittingdaily.com/content/InterweaveKnitsContributorGuidelines.aspx

Knit Now **Magazine**
http://www.knitnowmag.co.uk/contact-us

Knitter's **Magazine**
http://www.knittinguniverse.com/knitters_callfordesigns/

The Knitter **Magazine**
http://www.theknitter.co.uk/faq/

KnitScene **Magazine**
http://www.knittingdaily.com/content/KnitsceneContributorGuidelines.aspx

Knitty **Online Magazine**
http://www.knitty.com/subguide.php

Let's Knit **Magazine**
http://www.letsknit.co.uk/contact

PieceWork **Magazine**
http://www.interweave.com/needle/piecework_magazine/contributor_guidelines.asp

Twist Collective **Online Magazine**
http://twistcollective.com/collection/index.php/about/39-about/95-submissions

Vogue Knitting/Knit Simple
http://www.vogueknitting.com/design_submissions.aspx

References & Resources

Miscellaneous

Folk Shawls by Cheryl Oberle. Interweave, 2000. ISBN 978-1883010591.

On Grading & Garment Fit

The Knitter's Guide to Sweater Design by Mary Ann Davis and Carmen Michelson. Interweave, 1989. ISBN 978-0934026338.

Knitting Pattern Essentials: Adapting and Drafting Knitting Patterns for Great Knitwear by Sally Melville. Potter Craft, 2013. ISBN 978-0307965578.

Big Girl Knits: 25 Big, Bold Projects Shaped for Real Women With Real Curves by Jillian Moreno and Amy R. Singer. Crown Publishing, 2009. ISBN 9780307586377.

Knitwear Design Workshop: A Comprehensive Guide to Handknits by Shirley Paden. Interweave, 2012. ISBN 978-1596687967.

Sweater Design in Plain English by Maggie Righetti. St. Martin's Griffin, 2011. ISBN 978-0312622916.

Little Red in the City by Ysolda Teague. Ysolda Teague, 2011. ISBN 978-0956525826.

"Multisize Me: Grading a Knitting Pattern for Multiple Sizes" by Jenna Wilson. *Knitty*, Spring 2008.

http://www.knitty.com/ISSUEspring08/FEATspr08TBP.html

Craft Yarn Council of America
http://www.yarnstandards.com
http://craftyarncouncil.com/sizing.html

American Society for Testing and Materials
http://www.astm.org/

General body size information
http://www.eileencaseycreations.com/
measurements/

"Foot Sizing Survey Results" by Kate Atherley.
Knittyblog, July 16, 2012.

http://knittyblog.com/2012/07/foot-sizing-
survey-results-contest/

Tot Toppers Sizing Chart
http://www.tottoppers.com/sizing/

Photography

**"10 Ways to Instantly Improve Your Finished
Object Photography"** by Caro Sheridan. Petit
Purls, Fall 2011.
http://www.craftsy.com/class/
Shoot-It-A-Product-Photography-
Primer/90?ext=shootit&utm_
source=Instructor-Caro%20
Sheridan&utm_medium=Link&utm_
campaign=Affiliate

"Shoot It! A Product Photography Primer"
by Caro Sheridan.
http://www.craftsy.com/class/
Shoot-It-A-Product-Photography-
Primer/90?ext=shootit&utm_
source=Instructor-Caro%20Sheridan

Charting Fonts & Software

Aire River's Knitting Font
http://home.earthlink.net/~ardesign/knitfont
.htm

XRX Knitter's Symbol Font
http://www.knittinguniverse.com/
downloads/KFont/

Chart Minder
http://chart-minder.com/

KnitVisualizer
http://www.knitfoundry.com/software.html

PatternGenius
http://www.patterngenius.com

Intwined Pattern Studio
http://intwinedstudio.com

Stitch Maps
http://stitch-maps.com

Stitch Mastery
http://www.stitchmastery.com

Layout

Butterick's Guide to Practical Typography
http://practicaltypography.com/

Lynda.com Online Learning Company
http://www.lynda.com/

**Fontsquirrel.com 100% Free for Commercial
Use**
http://www.fontsquirrel.com

Submitting to a Publication

"Tutorial: Creating a Magazine Submission"
http://www.fourth-edition.co.uk/?p=6105

Knit Now's Submission Tips for Designers
http://www.knitnowmag.co.uk/item/193-
submission-tips-for-designers

Selling Online

Ravelry
http://www.ravelry.com

Patternfish
https://www.patternfish.com

Etsy
http://www.etsy.com

On Copyright

Creative Commons
https://creativecommons.org

Creative Commons Licenses
http://en.wikipedia.org/wiki/Creative_
Commons_license

"Ask a Lawyer! Knitting and Copyright"
http://www.vogueknitting.com/magazine/
article_archive/ask_a_lawyer_knitting_and_
copyright.aspx

Copyright Matters Ravelry Group
http://www.ravelry.com/groups/copyright-
matters

Library of Congress
United States Copyright Office
http://copyright.gov/

Copyright Law of the United States
http://www.copyright.gov/title17/

**Canadian Intellectual Property Office
Copyright**
http://bit.ly/1B36SRc

Canada Copyright Act
http://laws-lois.justice.gc.ca/eng/acts/C-42/
Index.html

**Canadian Artists Representation/
Le Front des Artistes Canadiens**
http://www.carfac.ca/

Index

For every knitter who has ever worked from a pattern.

Acknowledgments

With many thanks to everyone who supported me on this project.

My book team: Zabet Groznaya, Kim Werker, Allison Thistlewood, and Krystal London.

My inspiration: All my knitting students and anyone whose patterns I have ever edited. And special thanks to those knitters who shared their rants and raves with me for inclusion in the book.

My readers: Cari Angold, Rayna Curtis Fegan, Beth Graham, Janelle Martin, Kim McBrien-Evans, Lynne Sosnowski, Karie Westermann, Keri Williams, and Edna Zuber.

Experts who were willing to be consulted and quoted: Ruth Garcia-Alcantud, Kara Gott Warner, Elizabeth Green-Musselman, Zabet Groznaya, Nadia Majid, Kim McBrien-Evans, Amy Palmer, Emily Ringelman, Caro Sheridan, Lynne Sosnowski, Jenna Wilson, and Woolly Wormhead.

Fellow designers and those who provided help with my research: Lorilee Beltman, Anne Berk, Donna Druchunas, Fiona Ellis, Katya Frankel, Deb Gemmell, Julia Grunau, Kate Heppell, Hunter Hammersen, Melissa Leapman, Lucy Neatby, Laura Nelkin, and Lindsay Stephens.

Anne Blayney for being able to draw and Avalon Sandoval for having time to knit.

My former and current colleagues at *Knitty*: Liz Ashdowne, Ruth Garcia-Alcantud, Ashley Knowlton, Mandy Moore, Jillian Moreno, and Amy Singer.

My home team: Norman, Anna at Café Unwind for the Friday coffee breaks, and Dexter the dog for not trying to eat this one.

About the Author

Armed with a degree in pure mathematics from the University of Waterloo and training in fashion design from George Brown College in Toronto, Kate Atherley has a very unusual skill set. Combine that with more than ten years working as a technical writer and marketing communications specialist in the software industry, ten years' experience teaching knitting, and nearly ten years working as a technical editor for knitting patterns, and you've got a truly one-of-a-kind perspective.

As the Managing Technical Editor for Knitty.com, she has edited literally thousands of knitting patterns for designers, yarn companies, and publishers. She's worked with designers just launching their careers, and with some of the most well-known names in the business, including Annie Modesitt, Stephanie Pearl-McPhee, and Laura Nelkin. She's edited a number of patterns for Interweave magazines, and entire books for Cooperative Press and Potter Craft.

She teaches regularly at stores around Ontario, and at events all over North America including Knit Social's Knit City in Vancouver, Vogue Knitting Live in Chicago and NYC, Interweave Knitting Lab in California and New Hampshire, and Yarn Fest in Colorado. One of her proudest moments was selling out five classes at Sock Summit 2011. She also speaks at guilds around Canada and the United States

Kate's first book, *Beyond Knit and Purl*, is aimed at knitters who are looking to build their skills from the basics of the knit stitch to being able to work from patterns. The book provides lots of fantastic how-to photos, clearly demonstrating all the key techniques: increasing and decreasing, working in the round, specialty cast-ons, through to working cables, lace, and colorwork. And it's not just how-tos: there are

Connect with Kate online!

 kateatherley.com

 kate.atherley@gmail.com

 @kateatherleyknits

 @kateatherley

great patterns spread throughout to support the educational material, ranging from ultra-simple dishcloths up to shawls, socks, mittens, and a first garment: a classic top-down one-piece baby sweater, fully explained.

Her second book, *Knit Accessories: Essentials and Variations,* is the book that will help you use up your stash, refresh the mitten cupboard at the start of winter, and make gifts for all your friends and family. Featuring multiple designs of essential accessories: hats slouchy and fitted, mittens and fingerless mitts, socks toe-up and top-down, leg warmers, scarves, cowls, each in multiple gauges of yarn and multiple sizes, it has all the go-to patterns.

Kate's third book, *Custom Socks: Knit to Fit Your Feet,* is a master class in sock knitting. In it, she teaches knitters of all levels the skills and tools they need to understand sock fit, and to knit a pair of socks that fit properly. Featuring 2 master sock patterns: top-down and toe-up, in 12 sizes and 9 gauges, and 12 other patterns for beautiful and fully customizable socks, this book has everything you need to make socks that truly fit.

Metric Conversion Chart

To convert ⟶	to ⟶	multiply by
Inches	Centimeters	2.54
Centimeters	Inches	0.4
Feet	Centimeters	30.5
Centimeters	Feet	0.03
Yards	Meters	0.9
Meters	Yards	1.1

www.interweave.com

Originally published as Pattern Writing for Knit Designers: Everything You Didn't Know You Needed to Know by Kate Atherley/Wise Hilda Knits, Toronto, Canada.

19 18 17 16 5 4 3 2

Distributed in Canada by Fraser Direct

100 Armstrong Avenue

Georgetown, ON, Canada L7G 5S4

Tel: (905) 877-4411

a content + ecommerce company

Distributed in the U.K. and Europe by F&W MEDIA INTERNATIONAL

Brunel House, Newton Abbot, Devon, TQ12 4PU, England

Tel: (+44) 1626 323200, Fax: (+44) 1626 323319

E-mail: enquiries@fwmedia.com

Distributed in Australia by Capricorn Link

P.O. Box 704, S. Windsor NSW, 2756 Australia

Tel: (02) 4560 1600, Fax: (02) 4577 5288

E-mail: books@capricornlink.com.au

SRN: 16KN13

ISBN-13: 978-1-63250-434-0

PDF SRN: EP13248

PDF ISBN-13: 978-1-63250-435-7

EDITED BY Christine Doyle

DESIGNED BY Courtney Kyle

Photographs © Caro Sheridan and Gillian Martin
Author photograph © Amy Singer